ON PHOTOGRAPHIC
COMPOSITION

Otto Litzel

ON PHOTOGRAPHIC
COMPOSITION

by Otto Litzel, FPSA, ARPS

AMPHOTO

American Photographic Book Publishing Company, Inc.

Garden City, New York

DEDICATION
This book is dedicated to my wife
whose contributions to the writing of it
were many and varied.

Library of Congress Catalog Card No. 74-78035
ISBN: 0-8174-0572-0.

Manufactured in the United States of America.

Book design by Harushi Tetsuka with
Patricia Maye.

CONTENTS

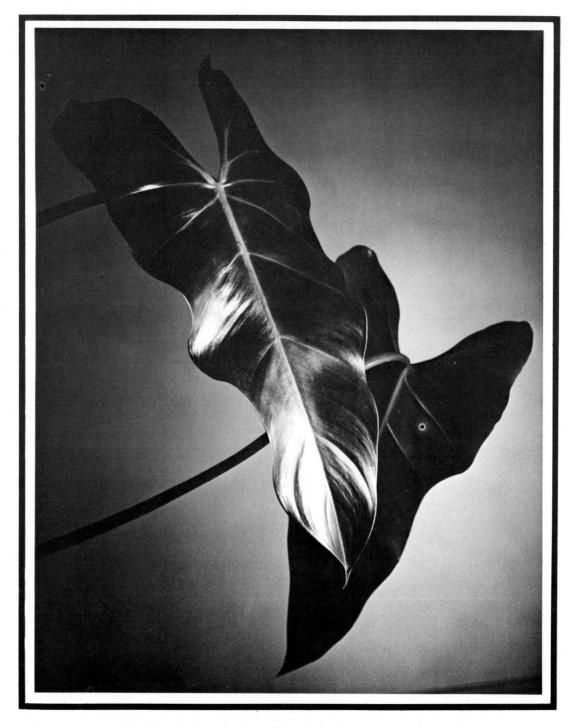

TWO LEAVES

The Plates

o o o

Foreword

Everything in nature is created after a basic design. Almost everyone is born with a natural instinct for pleasing composition but it takes study to develop the instinct into a skill. For the artist-photographer to express himself fully, he must have a proper knowledge of composition and a mastery of the many techniques available to him.

He must be able to analyze what he sees in relation to what his camera will record in order to choose the best camera position. His technical knowledge and imagination will help him to visualize the finished print. And, he will find that the best way to learn about a subject is to study its history.

The earliest evidence of the beginnings of man's creativity is found in the caves of southern France and northern Spain. It indicates that the caveman was a keen observer, and enough of a craftsman, to paint what he saw. The paintings do not appear as decorations in the living quarters but in other areas, which are believed to have been for ceremonial use.

The cave painter had no knowledge of mechanical or atmospheric perspective. Large figures always appeared on correspondingly large, flat areas on the cave wall; and smaller figures were painted on small areas.

Perhaps over-population caused the cave dweller to abandon his caves and move down to the low country, where he was forced to build living quarters for his family and tribe. There, for the first time, man confronted the need for controlling space and shape.

Some thousands of years later, the Egyptians had developed a much greater understanding of space control. In their paintings and engravings they placed the foreground figures on a baseline and indicated depth by placing middle and background figures in rows, one band above another. A large figure did not mean that the individual was closer to the foreground than the smaller figures; it indicated his greater importance in political, religious or social life. Every figure was painted or incised with the face in profile, the eye and upper torso in full view and the lower part of the body again in profile.

The Egyptian influence was felt in all the early Mediterranean cultures. It was only in the latter years of the Greek culture that painted figures were rendered with more roundness and depth.

The advanced Greek art undoubtedly had a great influence on subsequent Roman art. The frescoes found in Pompeii and Rome clearly show a continuation of the Greek trend toward realistic forms. This artistic and spatial chronology—from caveman to Egyptian to Greek and Roman—can be studied by visiting museums where artifacts from these civilizations are on display.

The period following the decline of the great civilizations of Greece and Rome was marked by an interruption in the artistic evolution described thus far. During this time of strife and conflict, much classical art was destroyed, and the works of art created during these so-called "dark" ages emphasized overall surface decoration and eastern animal and plant motifs executed without regard for space.

The interest in spatial representation came again to the fore during the twelfth and thirteenth centuries when wealthy European families employed artists to decorate the interiors of their homes. The paintings, covering an entire wall, created the illusion of the continuation of the room itself. The artist emphasized the important persons of the household by placing them quite obviously in the background and yet enlarging them, while keeping the servants in the foreground small. This contrary juxtaposition of size and location caused distortion which is a technique artists have used all through the ages to draw attention to their main theme.

The deepest penetration of picture space was achieved by Renaissance artists using a novel, one-point perspective. *The Last Supper* by Leonardo da Vinci is an excellent example of the technique. A close study of the painting will prove that all the lines, actual or implied, go directly to a point on the horizon just be-

hind the face of Jesus. Inspection will also bring the realization that this picture is perfectly balanced, with the figure of Jesus in the center and the Apostles placed on either side in groups of three.

From the fifteenth to the middle of the nineteenth century, artists copied nature as closely as possible. Sketching was done out-of-doors, but the painting was finished in the studio and all movable objects were brought there to be copied. Through this period, there came into general use an invention called the *camera obscura,* a forerunner of the camera as we know it today, which helped the artist to sketch more accurately.

The development and refinement of the camera for picture taking, rather than simply as an artist's accessory, began a new era in the visual arts.

The early photographer was usually a trained artist who became intrigued by the camera and its possibilities. Naturally, he was visited quite often in his studio by his artist friends, who also became excited by the new visual world which the camera revealed.

Suppose you had never seen an image on the ground glass of a camera; then one day, while moving the bellows back and forth, you noticed something you had never conceived to be possible. The image in the foreground appeared sharp and detailed, whereas the back-ground grew fuzzier and fuzzier as it receded into the distance. Here was a way to isolate a major shape in painting!

It is not an unreasonable theory. Cezanne's painting *Peasant in a Blue Blouse* could not have been conceived before the introduction of photography. And, who knows? Perhaps Seurat looked at a completely out-of-focus image in the ground glass, saw the circles of confusion dancing therein, and imagined a painting built up of one bright dot of color next to the other.

The nineteenth century photographer could not travel far afield because of his cumbersome equipment, so he photographed things he could find in his home environment. Conversely, a painter was freed from his studio by the introduction of the collapsible paint tube, so he went into the fields and the countryside to paint.

In 1874 a few of the struggling young painters of France—Cezanne, Monet, Renoir, Sisley, Degas and some others—had an exhibit of their paintings in the studio of the photographer G. F. Tournachon, better known as Nadar. It was during this exhibit that the term "Impressionism" first came into use.

The Impressionists felt that atmosphere and color in a painting were the most important considerations. One of their contemporaries, Paul Cezanne, did not share this concept. To him the organization and rendition of depth took precedence. After many years of study he resolved this spatial problem by using overlapping shapes. He, more than any of the other artists, felt that only the shape, the size and the texture of an object could be composed, not the object itself. He moved away from Paris and returned to his home town, where he worked alone until his death in 1906. While Cezanne was generally ignored in his own time, his theory of space influenced many future schools of art.

Cezanne's theory of showing depth by overlapping shapes was used by a group of early twentieth-century painters in Germany, who became known as Expressionists. Among them we find the names of such artists as Emil Nolde, Vasili Kandinsky, Lyonel Feininger, Franz Marc, and Paul Klee. Feininger and Klee became teachers at the Bauhaus, which was later dissolved by the Third Reich.

Photography, which had sponsored such a leap forward in painting, did not keep step with the new art movements. Early exhibit photographs looked like nothing more than reproductions of paintings done hundreds of years before.

The present-day photographer is in much the same place as the avant-garde painter of the nineteenth century—in a position to create a new visual world.

10

BENEDICTION

Components of Composition

The photographer is as deeply involved in composition as is his counterpart in the other graphic arts, because it is only through the correct composition of his work that he can express his ideas. It is incumbent upon both photographer and artist to know about the elements of composition and how to control them in order to make a clear, direct and visually strong statement.

These compositional elements are more real than the objects they represent. They are real and powerful visual forces. In order to control them the photographer must understand what they are and how to use them. The elements are the building blocks of creative art and are used in much the same way as a builder uses concrete, steel and glass. These building blocks are line and direction, shape and size, color and texture and tone value.

LINE AND DIRECTION

The language of lines is one of the oldest forces in art, capable of producing strong emotional reactions.

Vertical lines are dominant, dignified, noble. They are positive lines because they repeat the two vertical sides of the format. Tall trees and buildings, people who stand tall and erect, have a dignity all their own due to their dominant direction. Strong vertical lines serve as a unifying force in a composition.

Horizontal lines are usually thought of as restful or passive lines. But they can also suggest speed, as almost all movement is on a horizontal plane.

Diagonal lines are dynamic and suggest movement.

Curving lines are lines of beauty. They indicate movement and unify the straight-line elements of a composition into one rhythmic whole.

All these lines—vertical, horizontal, diagonal and curving—which are so important in graphic art, are replaced in photography by contours and the meeting of shapes which forms a line and forces the eye into the desired direction. This directional force can be intensified by increasing the tonal contrast of the shapes.

SHAPE AND SIZE

Size and shape are two of the most important elements in photographic art. *Shapes, not objects,* placed in their proper size relationship within a given area, form the foundation upon which the picture is built.

Suppose we compose an apple and a book. *Illustration A* shows a large white book standing against a textured background with an apple in front of it. We assume this is a good arrangement. *Illustration B* is also a composition of an apple and a book, but the grouping is very unsatisfactory because the size relationship between the shapes is too close.

This little exercise proves that we cannot compose objects. *Only shape, size and texture can be composed; not the object itself.* This is the key to the understanding of composition.

Camera position in relation to the nearest object is important because it controls size relationships with objects in the distance. Only a long distance between the camera and the nearest shape will flatten out the picture. A long focus lens can be used to obtain a larger image on the negative, but it is a fallacy to believe that the image created by a long lens is different from that of a short lens used at the same camera-to-subject distance. It is only the distance relationship between the farthest shape to the nearest shape and to the camera which controls size relationships. One of my own photographs, *Mighty Manhattan* (page 43), became very successful because I was forced to take it at a great distance from the nearest building. This print will be discussed in detail in another section.

Illustrations A and B, which demonstrate the visual effect of size relationships, are reproduced on the following page.

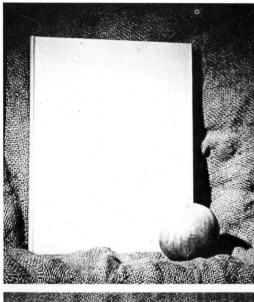

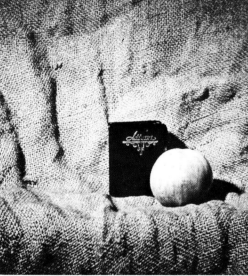

COLOR AND TEXTURE

Color is not important to the black-and-white worker except as it influences his choice of filters to render grey tones in their proper values.

Texture, on the other hand, is of great importance as it indicates depth on a two-dimensional print. Areas close to the camera should be sharp and distinct, becoming more diffused toward the distance. The proper use of texture can set a mood or tell a story; and it can create a surface so real that it invites people to reach out and touch it. A strong side light is essential to bring out texture to its fullest advantage.

For *Decay* (page 15) I used a 4″ x 5″ camera because the image on the large negative retains its sharpness even in a great enlargement. A small camera will record as sharply but will lose definition during the enlargement. The decaying stump was such a good background that I made several arrangements using materials at hand, but the print shown was the most effective.

Under the Oak Tree (page 17) is primarily a picture of texture. The extended depth of field was obtained by using the swings of a studio-type camera, making it unnecessary to stop down, and therefore a short exposure could be used to stop any possible movement from air currents.

In *Thin Ice* (page 19) a strong, low sun brought out the beautiful patterns in the fragile skin of ice. This picture proves again that beauty can be found everywhere, needing only an observant eye and the technical knowledge to capture it.

A late morning sun provided the soft light which brought out the texture of the rock in the construction picture, *The Drillers* (page 21). In all my construction pictures I used a 35mm camera. The scenes changed so rapidly that fast shooting was necessary. The film was Tri-X rated at ASA 650. This film speed, combined with the proper developer, gave me the fine grain negatives I needed for such great enlargements.

In portrait photography, to please the sitter, the texture of the skin should not be emphasized. This can be accomplished by taking the picture through a soft working lens, or if such a lens is not available, through a diffusion disk. However, when taking a portrait through a diffusion disk, the entire negative is soft and this is not always desirable. It is better to work with a sharp negative and attain the diffusion while making the enlargement. By using this method the print can be diffused sufficiently to please the subject during all or part of your enlargement exposure, and you will still have your sharp negative

for other prints. For, unlike the sitters, the judges in competition and salon photography prefer sharp rather than diffused prints.

TONE VALUE

Tone value is of utmost importance in black-and-white photography since every photograph can consist of up to fifty grey tones plus black and white.

The true translation of a full-color subject into the grey tones of the photograph can be controlled by the use of filters. We know that a filter will lighten its own color and darken its opposite on the color wheel. The effect of the filter can be observed by looking through it at the view to be photographed; the correct exposure is determined by taking a meter reading through the filter.

Suppose we see a landscape that we know would make a beautiful high key print; but there, on the left in front of a group of trees, is a large red billboard which would register dark grey or black on the print. The need to diminish the impact of the billboard is apparent. Since a filter lightens its own color, a red filter would be the first thought. But a filter also darkens the opposite color, in this case, the blue sky. This, of course, would destroy the high key effect. The solution is to use an orange filter, which contains red and there-fore will lighten the billboard somewhat while darkening the sky only slightly.

A large negative can be corrected by painting the light areas with new coccine to cut down the amount of light they will pass. Any further corrections can be made by applying some Farmer's Reducer or ferricyanide bleach selectively to dark areas on the print.

High Key: A high key picture is composed of soft, delicate grey tones with no dark areas. For all photographic work it is necessary to have a good normal negative, but for high key it is *imperative,* because the possibilities for improvement are limited. If you will refer to the "Notes on Development" in my earlier book, *Darkroom Magic* (Amphoto, 1967), you will find information on the proper development of film.

The high key technique is used to photograph blondes and children in order to emphasize the delicacy of their coloring. So as to avoid deep shadows it is helpful to have a ring of lights with the camera set in the center. My set-up consists of eight 250 watt flood lights.

In outdoor photography, all seasons of the year can supply us with high key subject matter, but winter is undoubtedly the best. The exposures are always critical and usually a light yellow filter is sufficient for correction.

White Park (page 25) was taken from a very high camera position in order to eliminate the distortion which would occur if it were located closer to the tree tops. The day was overcast after the snowfall, accounting for the over-all light grey tone. Only the footprints and the fence rails trace a darker pattern.

Contrast was reduced and a high key effect produced in *Winter Landscape* (page 23) by printing the enlargement through a sheet of sandblasted glass.

High key does not always have to be soft and grey; it can also be hard and brilliant. The *White Door* (page 27) was taken on a clear, sunny day. The intense sunlight shone on the newly painted door, illuminating the shadows and forming the outline of the design.

Symphony in Grey (page 29) was taken on a sunny, hazy summer day. It is the great distance between the camera and the shore line which compresses the haze and gives this picture its over-all high key tone. Compare this print with *Mighty Manhattan* (page 43) which was taken on a clear, cold day. The same view taken from the same camera position, but under different atmospheric conditions, produces a picture with entirely different values.

A high key print, like music played in the high register, establishes a feeling of lightness of spirit, joyousness, and gaiety.

Low Key: Low key is the exact opposite of high key. Light areas are eliminated because they would present a disturbing factor in the

predominance of dark tones which establish a somber mood. Again, correct exposure is very important. Overexposure makes the negative too dense and the resulting print would be too light for low key. On the other hand, underexposure will not register details in the dark areas. Thus, if the scene seems to have good possibilities it is advisable to bracket the exposure.

Coney Island (page 31) and *Moonlight Sonata* (page 33) were both exposed against the sun in the late afternoon and printed in low key, but there the similarity ends. The eyes of the viewer follow the sparkling waterline in *Coney Island* and he feels the eager mood of people hurrying to get in a last swim before nightfall. *Moonlight Sonata,* on the other hand, evokes a feeling of loneliness, of wild and windswept moors. These two prints demonstrate that low key can be used to initiate either an animated or a depressed mood.

There is a great difference between airline passengers. The photographers among them are always glued to the windows, watching and photographing the passing patterns below. The rest are either asleep or deep in their books. I saw and exposed the striking cloud effect, *Above the Night* (page 35), while on a lecture tour. No filter was used on the camera because the height at which we were flying made the sky almost black.

Portrait of Four Leaves (page 37), was photographed into the light which was streaming in from the window behind the plant. The back lighting brings out the structure of the leaves and creates an interesting shadow pattern. My attention was originally caught by the rim lighting which separates the leaves from the background. The exposure reading was taken from a position between the window and the leaves, with the meter directed toward the leaves.

One sunny day I came upon a small pond covered with water lilies which supplied me with many interesting pictures. I deliberately underexposed one particular negative because the meter was pointing into a very intense light, causing it to register too high. This would result in a very dense negative, impossible to use for the low key print which I had decided to make. *Lotus Leaves* (page 39) was not to be an illustrative nature shot but a dramatic pictorial presentation.

The elements we have discussed—line and direction, shape and size, color and texture, and tone value—are the foundation upon which the composition of a picture is built. They should always be kept in mind when one is outdoors, either with a camera or without. This is the only way to train oneself to observe and artistically analyze the omnipresent photographic possibilities.

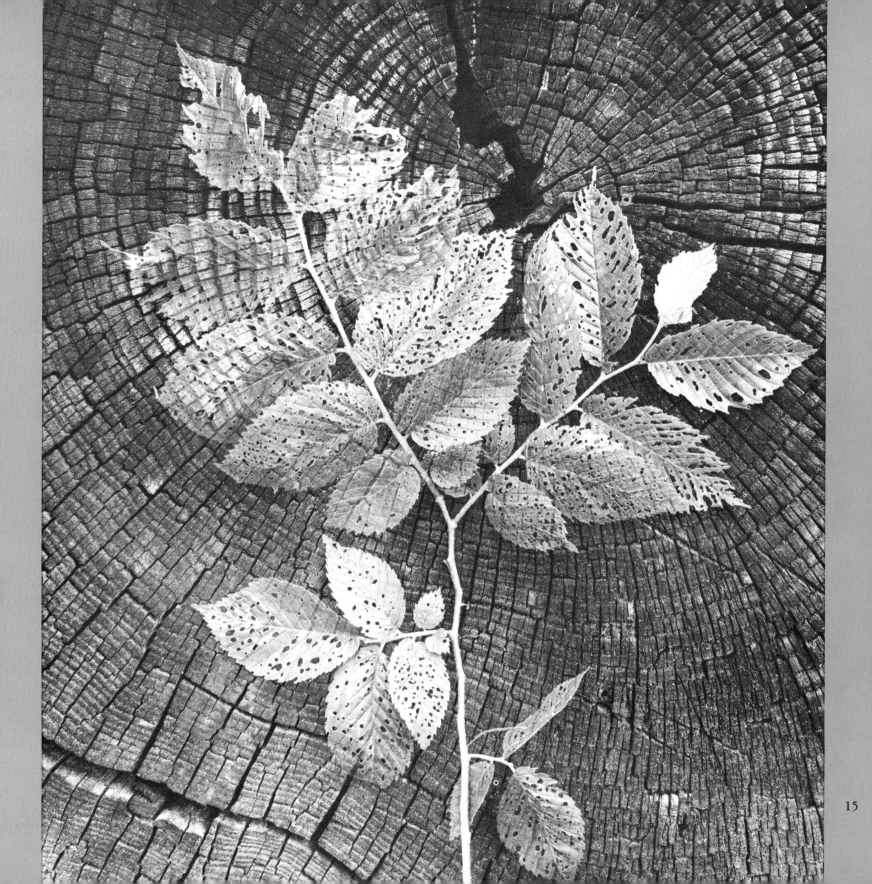

15

UNDER THE OAK TREE ►

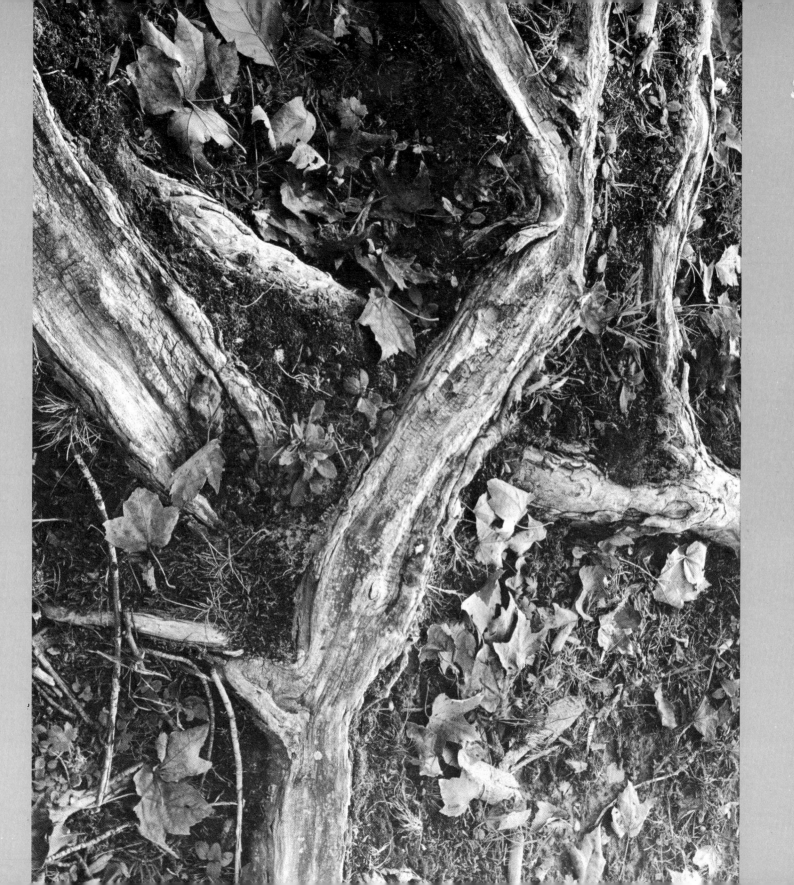

17

THIN ICE ▶

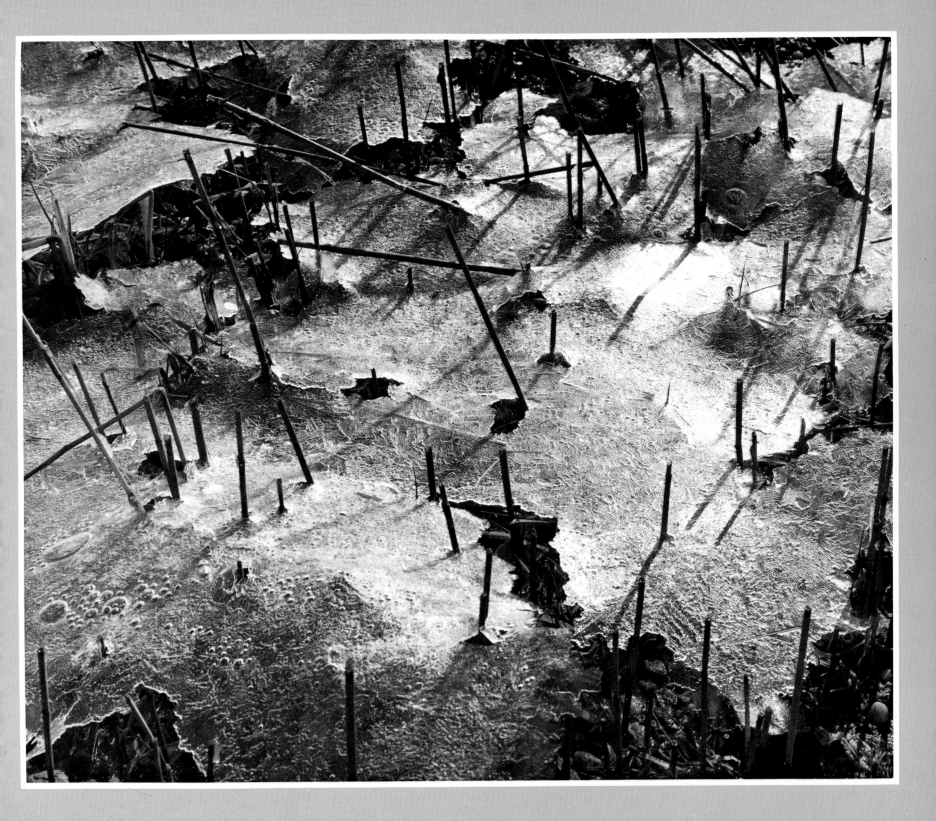

THE DRILLERS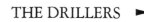

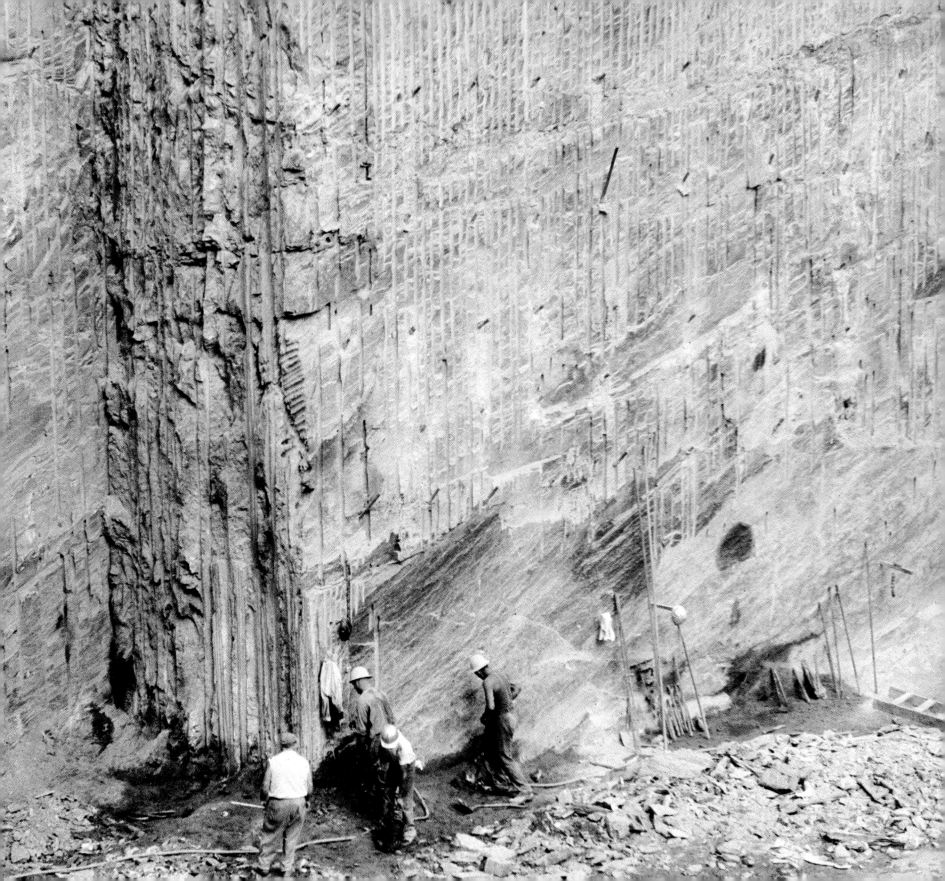

WINTER LANDSCAPE ▶

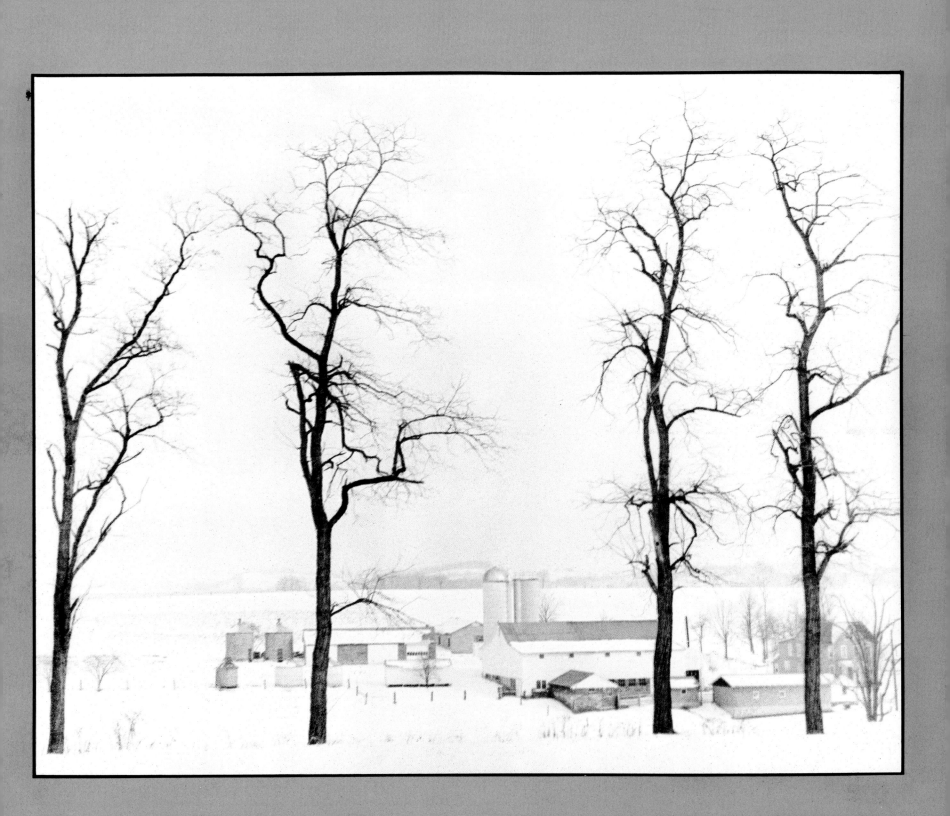

THE WHITE DOOR ►

SYMPHONY IN GREY ►

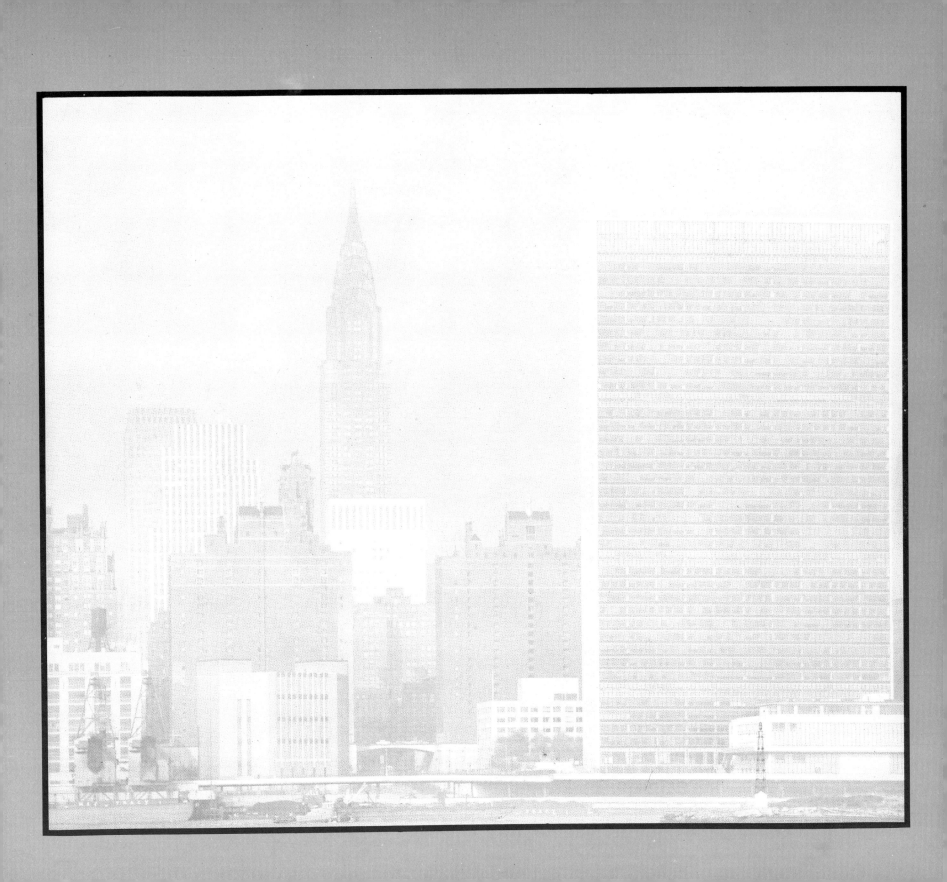

CONEY ISLAND ►

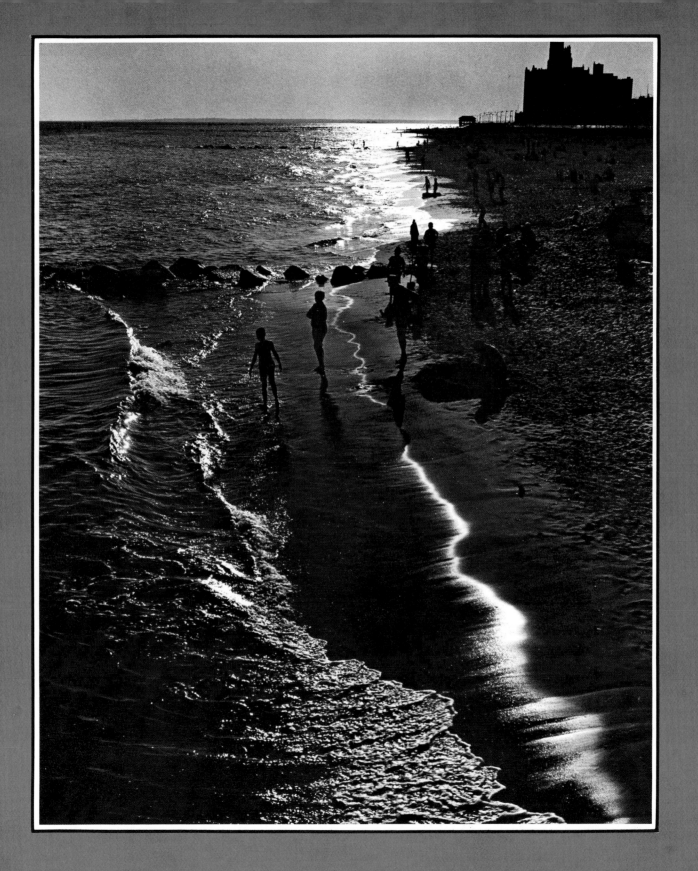

31

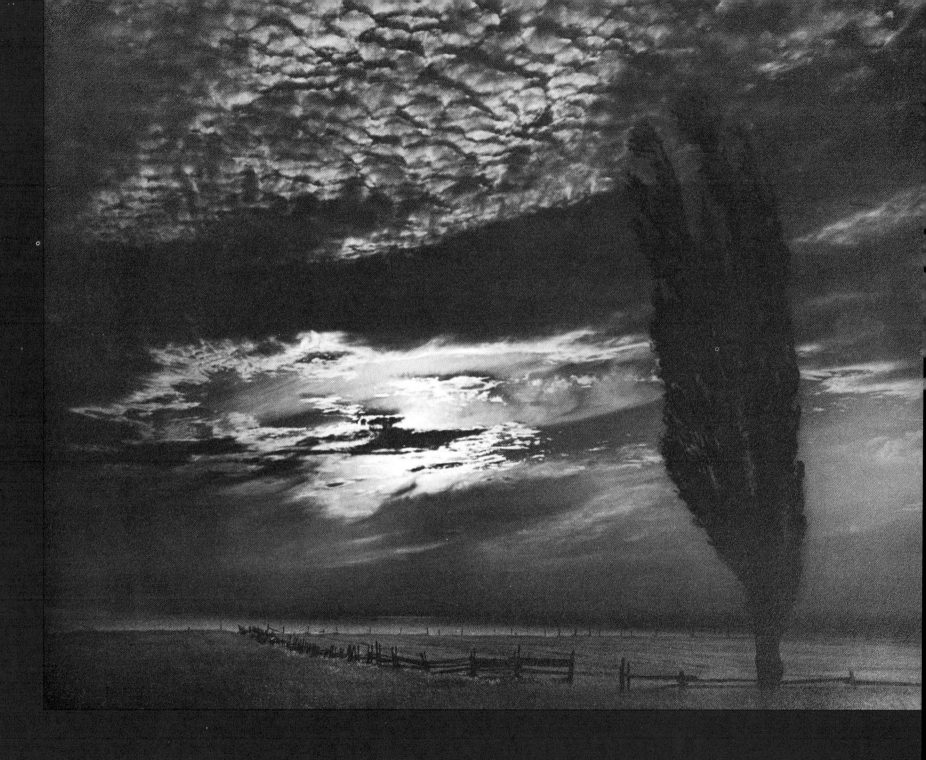

MOONLIGHT SONATA

ABOVE THE NIGHT ►

PORTRAIT OF FOUR LEAVES ►

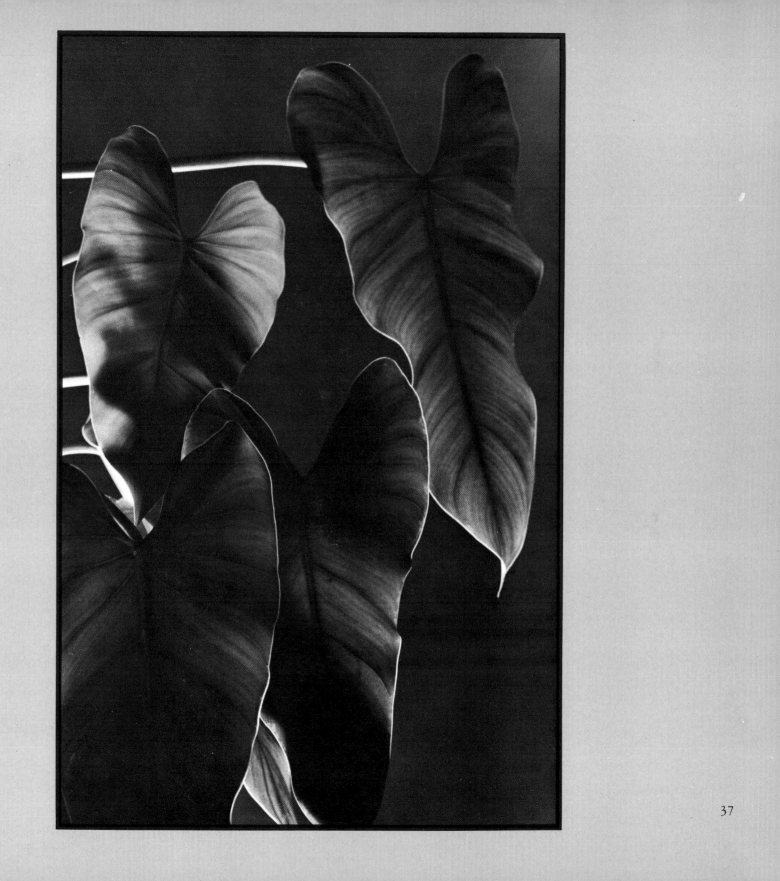

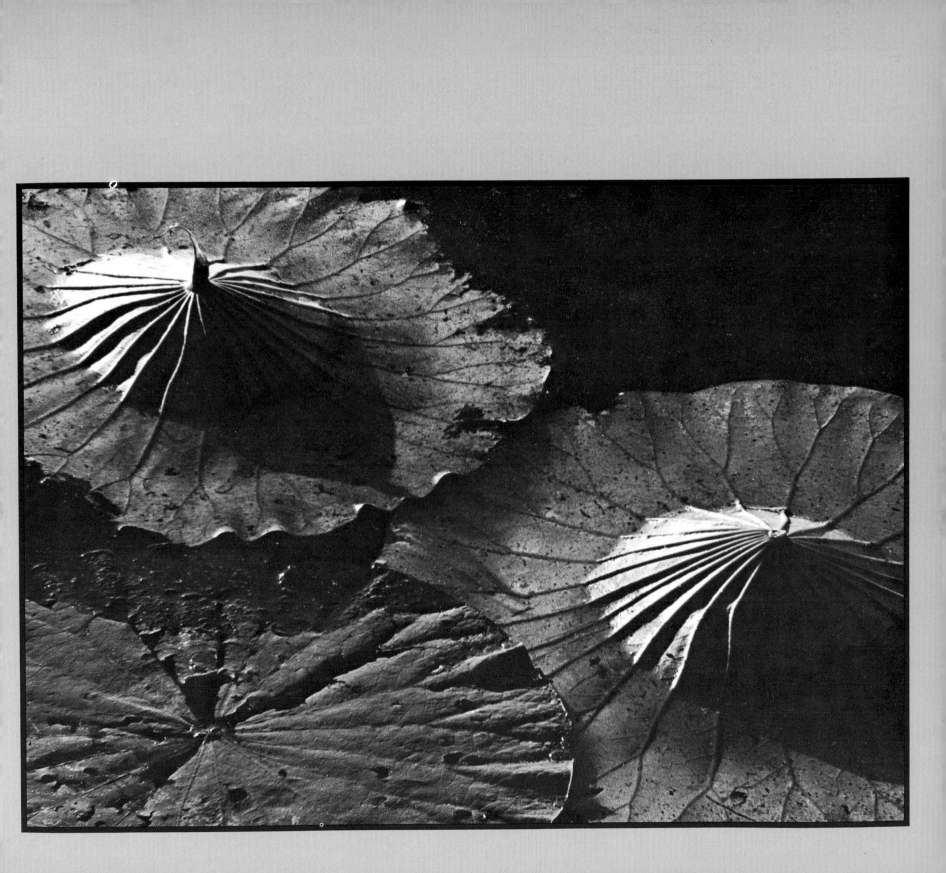

Principles of Composition

There is a certain relationship between all art forms; the difference lying only in the medium used. Many of the same terms are used in connection with poetry and music; music and the dance; literature and painting. Such terms as harmony, rhythm, interval and contrast are descriptive of all the arts.

In the graphic arts there are only three possible ways in which elements can be combined to obtain a particular effect.

1. They may be similar: Harmony
2. They may be quite different: Contrast
3. They may be identical: Repetition

These three principles are fundamental.

HARMONY

Harmony is the link between repetition and contrast. It always creates a feeling of peace and understanding. There are many harmonious combinations, such as:

Shapes: A circle and an oval
Line and direction: The rays of the sun
Value: The sky, which is always lightest at the horizon, darkening toward the apex
Function: Bottle and cork
Association: Triangle and a palm tree
Movement: The flow of water

In our picture taking we should always be aware of harmony in its varied manifestations. When using two negatives to form a single print, it is essential that they both contain harmonious shapes.

Mighty Manhattan (page 43) emphasizes the harmony of shape and value. The various shapes and grey tones of the buildings were rendered by the camera position, which was at a great distance from the closest buildings. This pulled the actual depth of the view forward, developed perspective by overlapping shapes, and eliminated the normal diminution in size of the buildings in the distance. I used a 4″ x 5″ camera, but any other size camera would have gotten the same effect if placed in the same position.

Light and shadow produce the three-dimensional quality in any photograph and, in available-light photography, it is often essential to wait for the sun to reach a certain desired position. I had to wait a considerable time for it to arrive in the right position to model the buildings in this shot. The effort proved worthwhile. This picture was sent to salons all over the world and it was never rejected.

In *Convoy* (page 45) we have an example of harmony of association. The tugboat and its accompanying seagulls were isolated by the use of a long lens with a narrow angle of view, the camera being placed at a great distance from the subject. The exhibit print was blue-toned to emphasize the atmospheric haze.

The Dance (page 46) and *Fantasia* (page 47) are excellent examples of harmony of movement. *The Dance* was created by one drop, and *Fantasia* by two drops of india ink in a glass of water. The view camera was placed very close to the glass in order to get a large image on the negative, and a short exposure arrested the movement of the ink. A sand-blasted sheet of glass standing close behind the water glass evenly distributed the light of a flood lamp about three feet away. (The pictures are reproduced upside down to give an upward movement.) This technique of photographing liquid movement offers unlimited possibilities since there are never two pictures alike.

Other good subjects for pictures showing harmony of movement are reflections on wet pavements and in bodies of water. *Night People* (page 49) was taken one rainy night at Times Square in New York City. A very fast film was used to stop the motion. There was a great deal more included in the negative than is presented in this enlargement. Only the reflection is used, without the people caus-

ing it, and the print is shown upside down and in reverse.

Underwater Forest (page 51) is the reflection of tall trees in a small pond and it too is presented upside down. Great care was taken not to include the sun's reflection, as its brilliance would block out the image of the trees and create an ugly hot spot which could not be eliminated.

CONTRAST

To produce eye-catching photographs we must incorporate contrast into our compositions. The dictionary defines contrast as "opposition or juxtaposition of different forms, lines or colors in a work of art to intensify each element's properties and produce a more dynamic expressiveness." In photography it is defined as "the relative difference between light and dark areas on a negative or print."

Now let us see how we can use this knowledge and put it to work in our compositions. In our photography we will use contrast in a variety of ways.

Contrast may exist between size and shape; shape and value; size and value; and size, shape and value.

In order to exploit these combinations to their fullest extent, we must choose our camera position carefully and expose properly.

The composition of *City Boy* (page 55) and *The Connoisseur* (page 54) is based on the contrast of size and shape. The entire arrangement of *City Boy* consists of the small figure of the leaping boy as opposed to the huge angular crates. The contrasts of this simple composition carry a great impact. The rounded figure of the man in *The Connoisseur* contrasts in shape and size with the square or the abstract painting on the wall. Fortunately, the available light was strong enough to make a short exposure possible.

The contrasts of shape and value in *Boat Basin* (page 57) were obtained by printing the continuous tone negative on high contrast film in order to lose the middle tones. The high contrast print is now much stronger than one made from the original negative.

The Corridor (page 59) is another way of using contrasts of value and shape effectively—the white curtain blowing into the dark tones, curves against straight lines. Simplicity is this composition's strength. This is also the case with *The Stairway* (page 61).

The Family (page 62) provides the strong, dark shapes which contrast sharply with the soft, light values of the background. Once again a museum offered wonderful opportunities for picture taking.

In *Girl with Statue* (page 63), the young lady in the dark clothing, standing in the foreground, counteracts the pale abstract torso in the background. Although this picture depends on the contrast of size and value for its impact, there is also a harmony of movement in the curves of the girl and those of the torso.

The composition of *Ship's Chef* (pages 64-65) depends on the use of size, shape and value. The large, dark, uniform area of the ship's hull is in great contrast to the small opening in which stands a still smaller white-clad figure.

The composition of *Construction* (page 67) is a good example of the use of contrast in size, shape and value. The tremendous impact is gained through the juxtaposition of men and the huge, dark shape in the foreground. The composition is further strengthened by the black diagonal on the left, which is repeated by the twisted cables on the right. The dust of a recent explosion serves as a foil for the dark shapes in the foreground.

A study of the fundamentals of composition will lead to a heightened visual awareness and improved photographs.

MIGHTY MANHATTAN ►

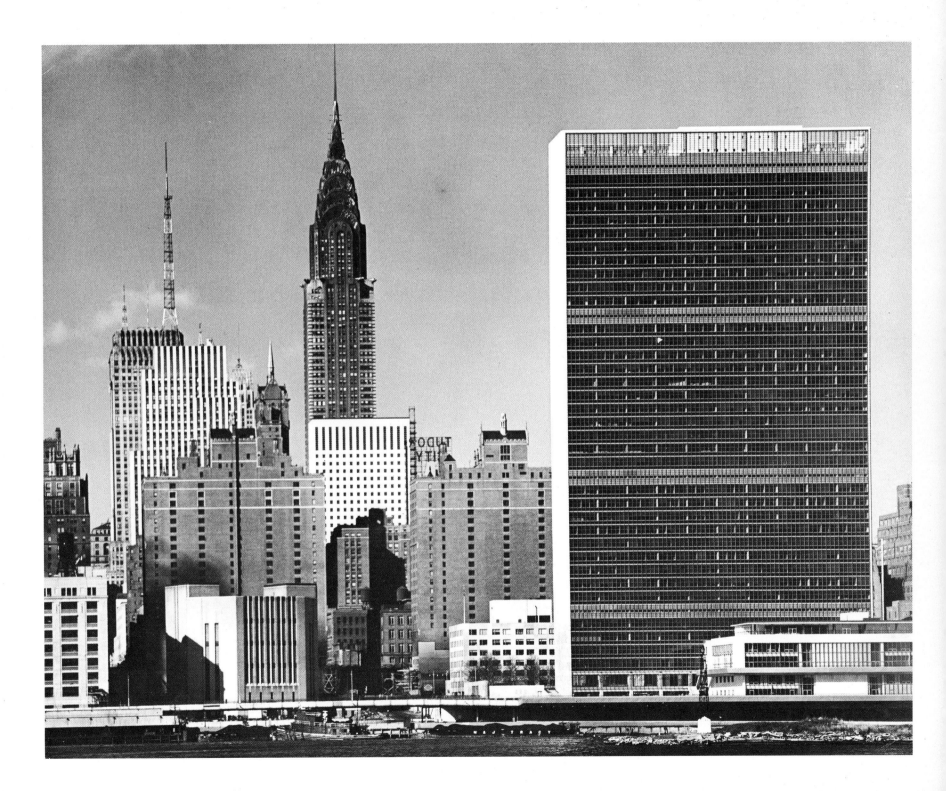

CONVOY ►

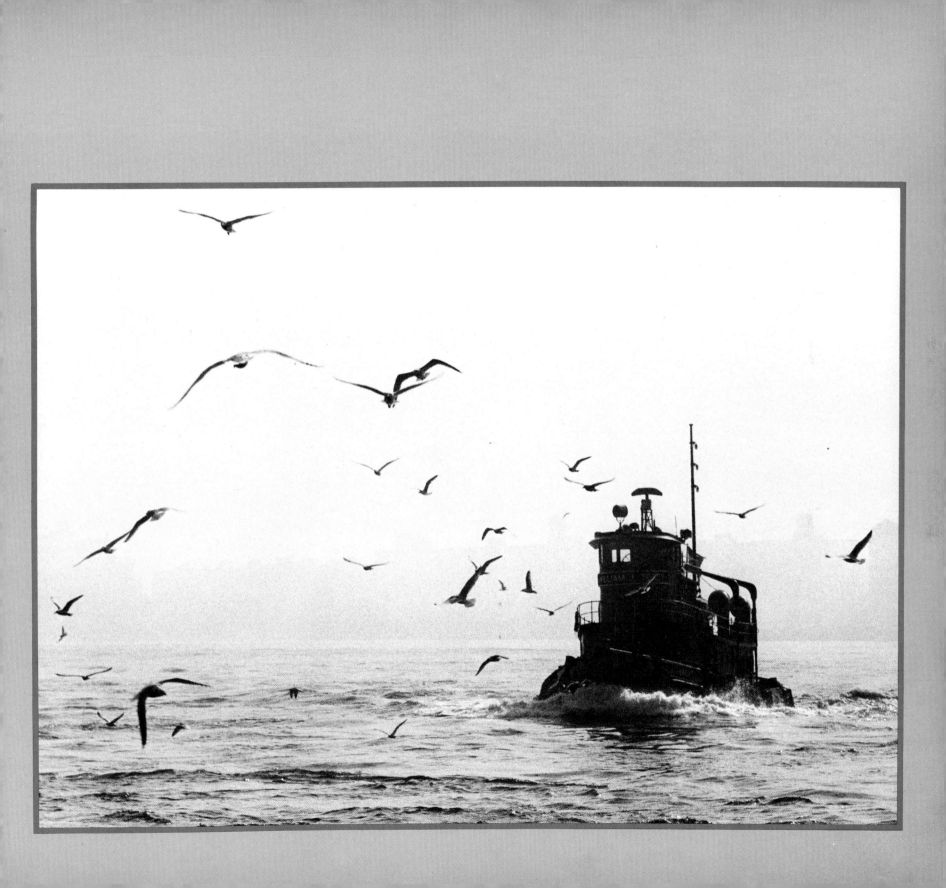

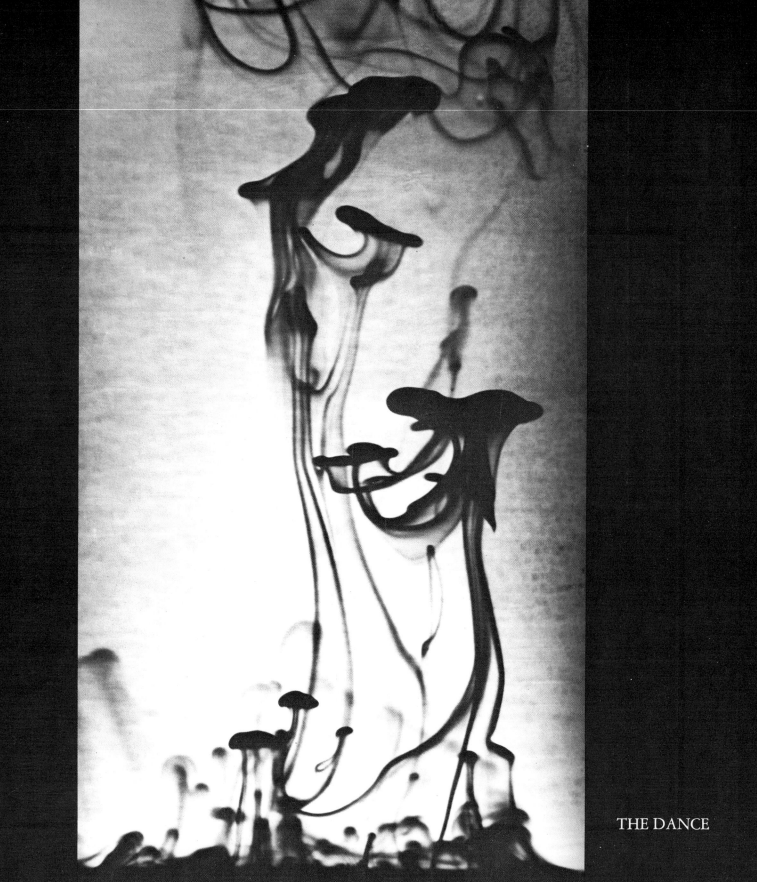

THE DANCE

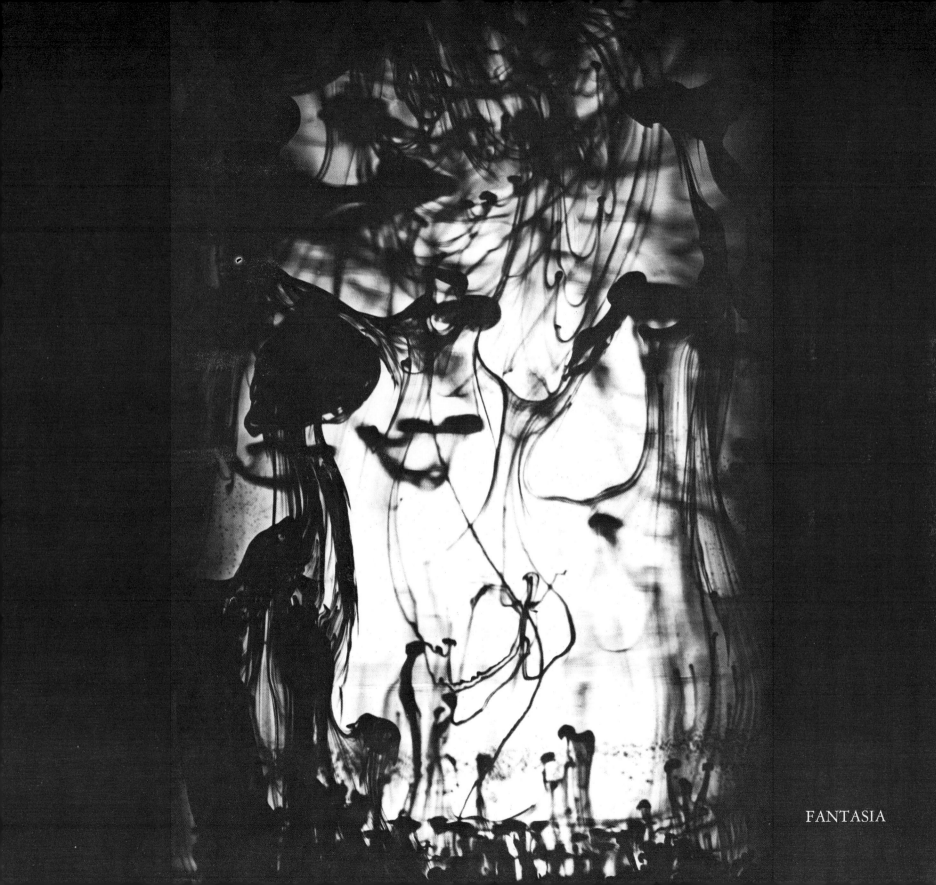

FANTASIA

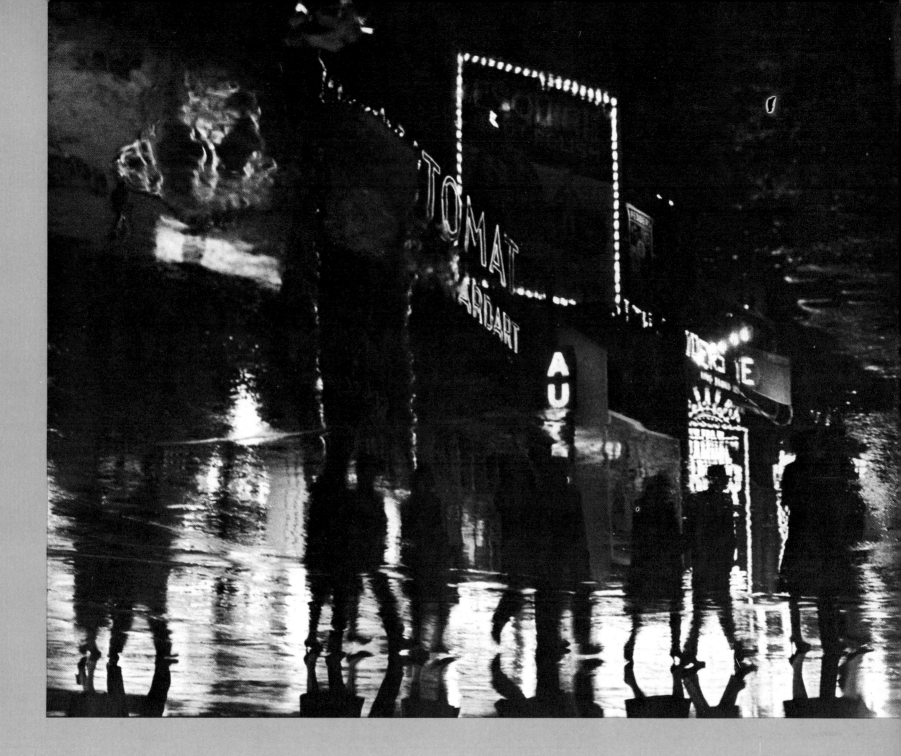

NIGHT PEOPLE

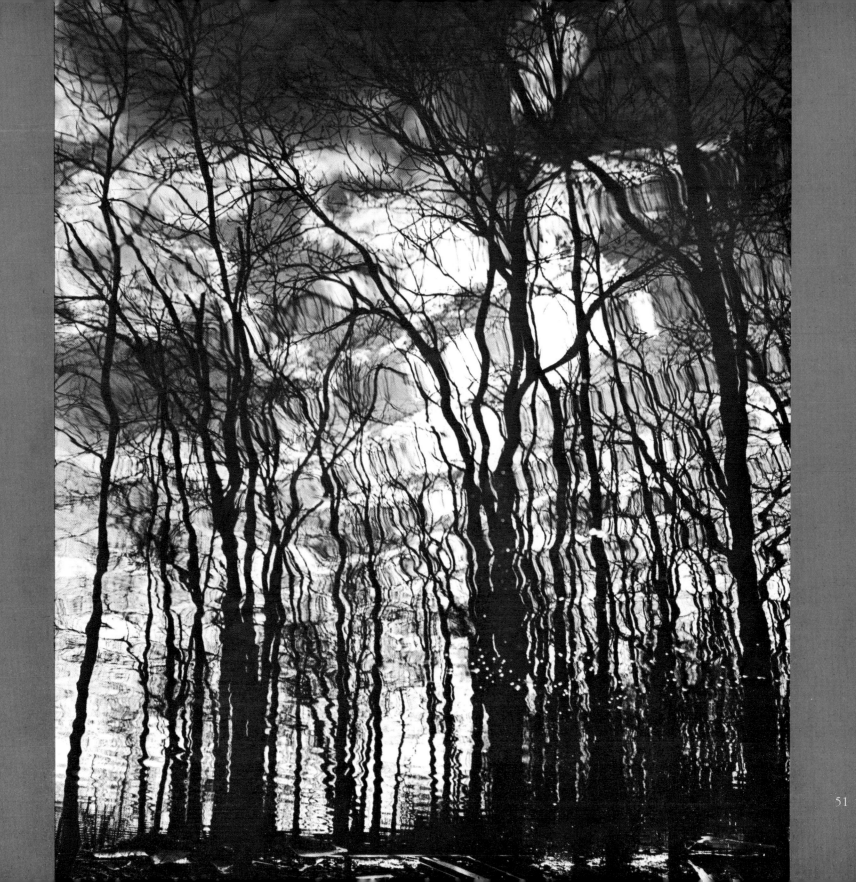

51

PORTRAIT

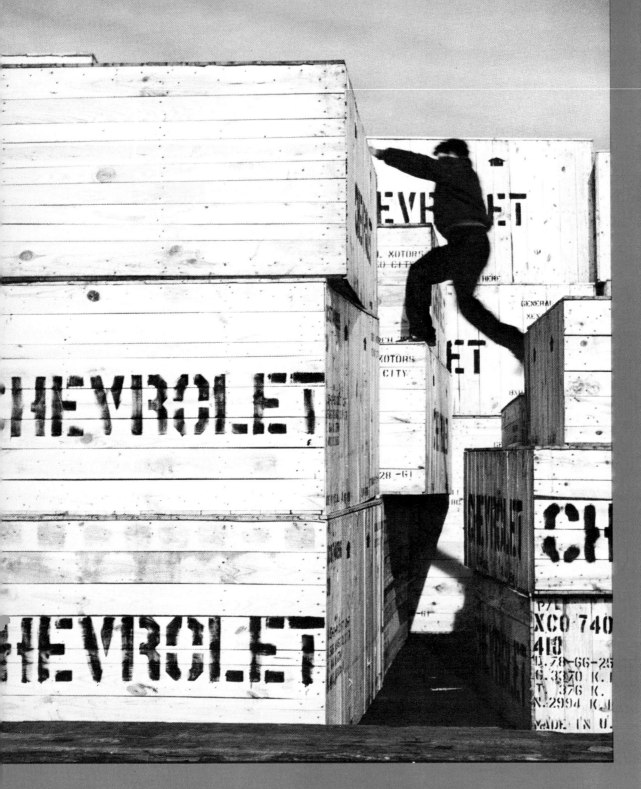

CITY BOY

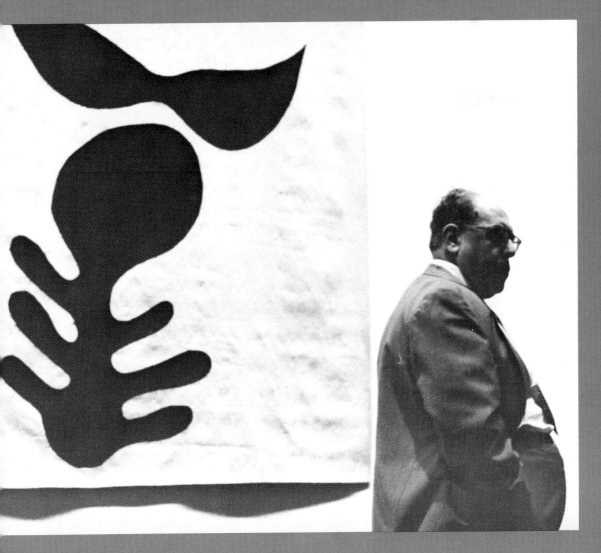

THE CONNOISSEUR

BOAT BASIN ▶

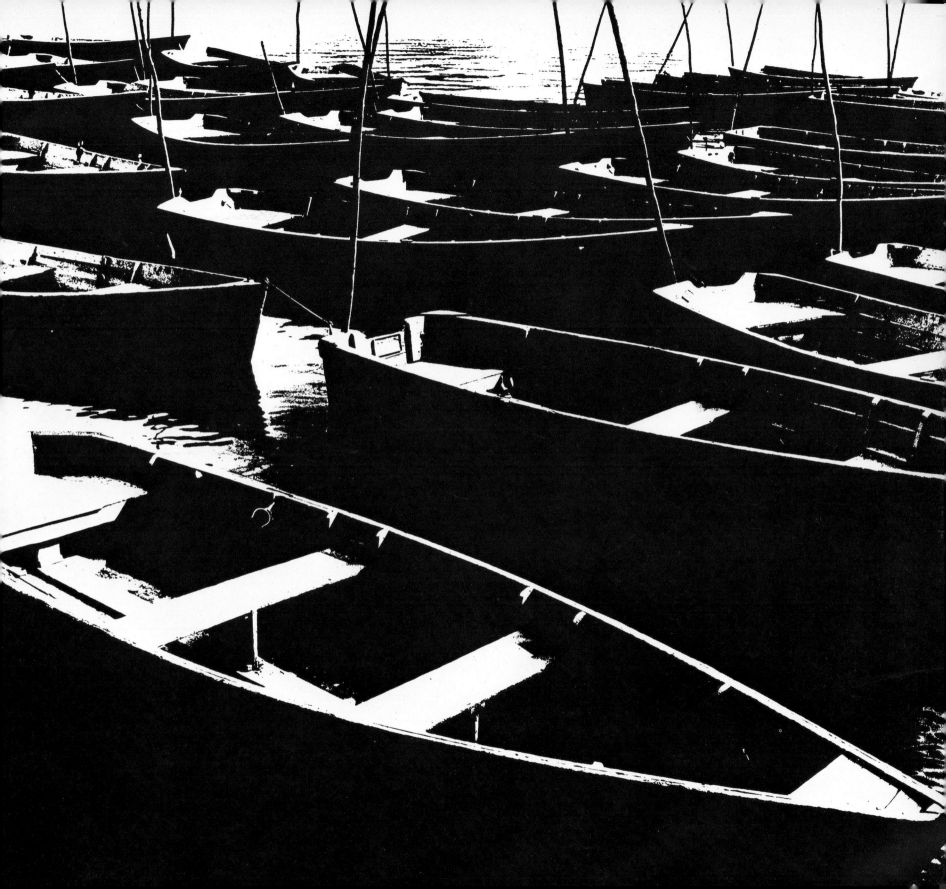

THE CORRIDOR

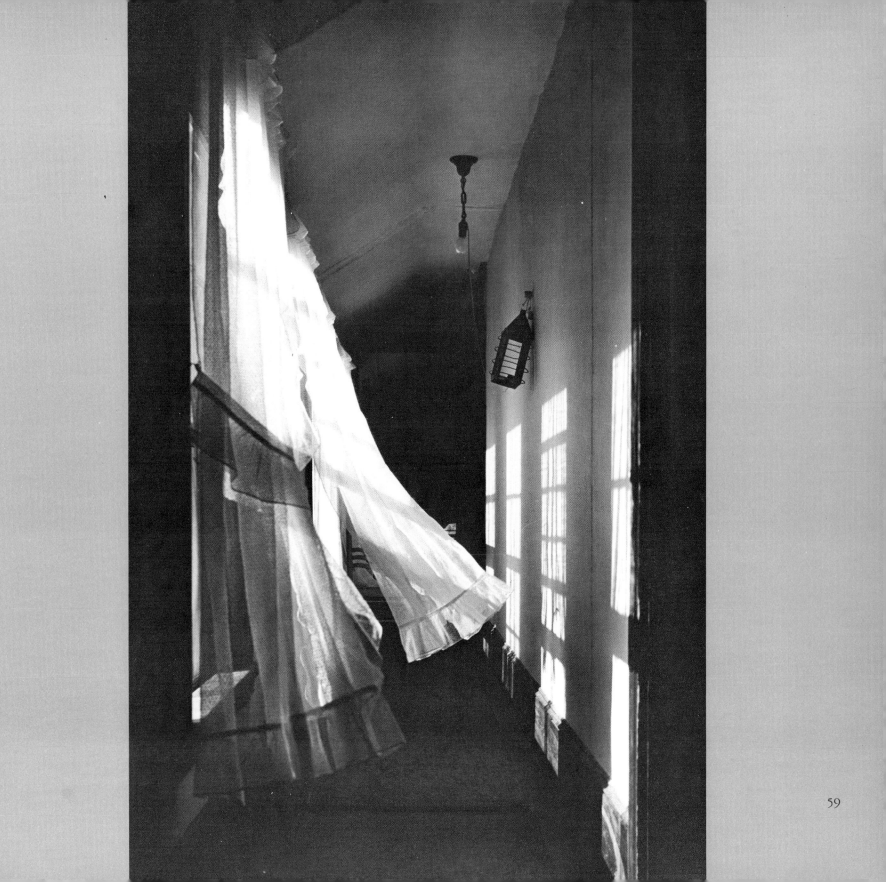

THE STAIRWAY ►

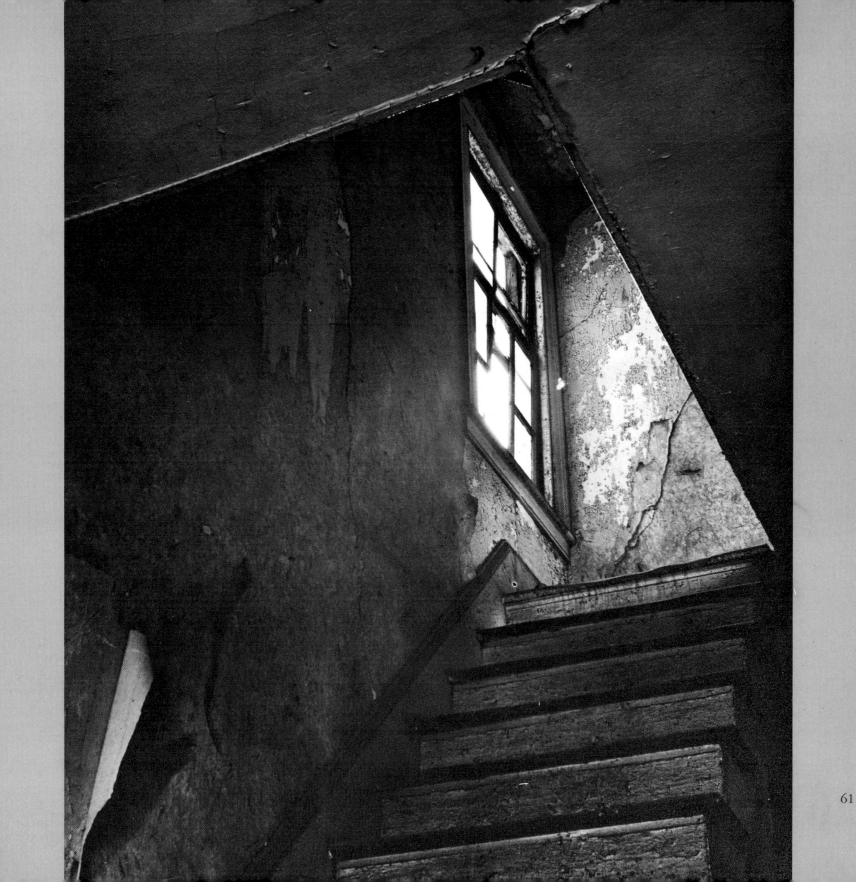

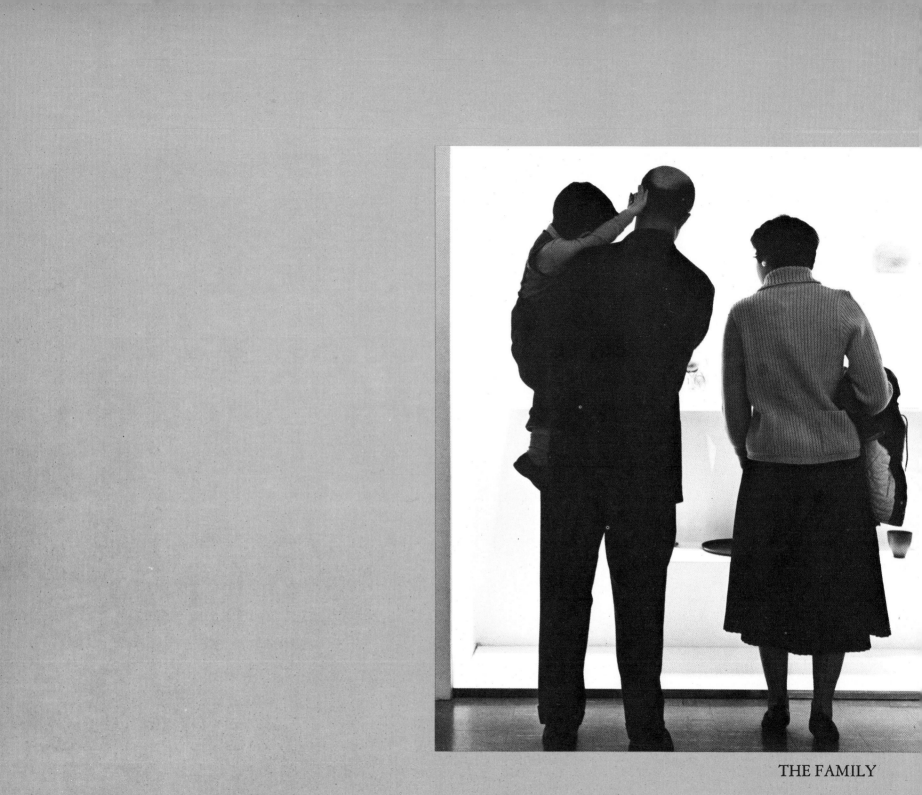

THE FAMILY

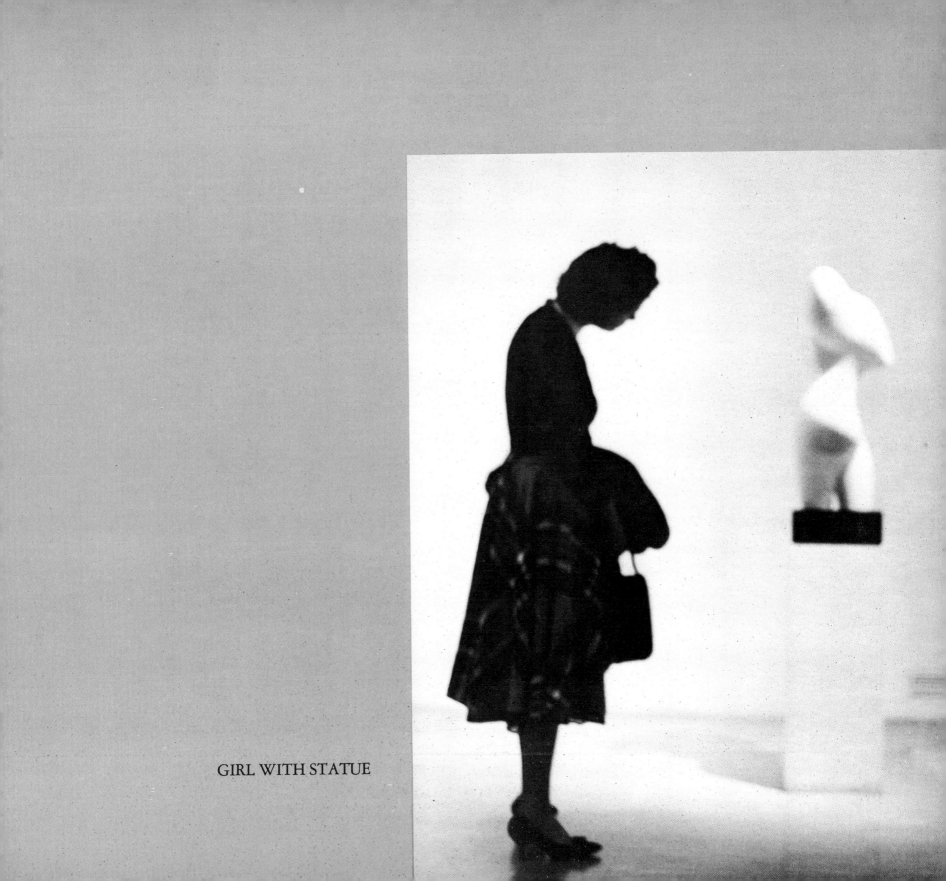

GIRL WITH STATUE

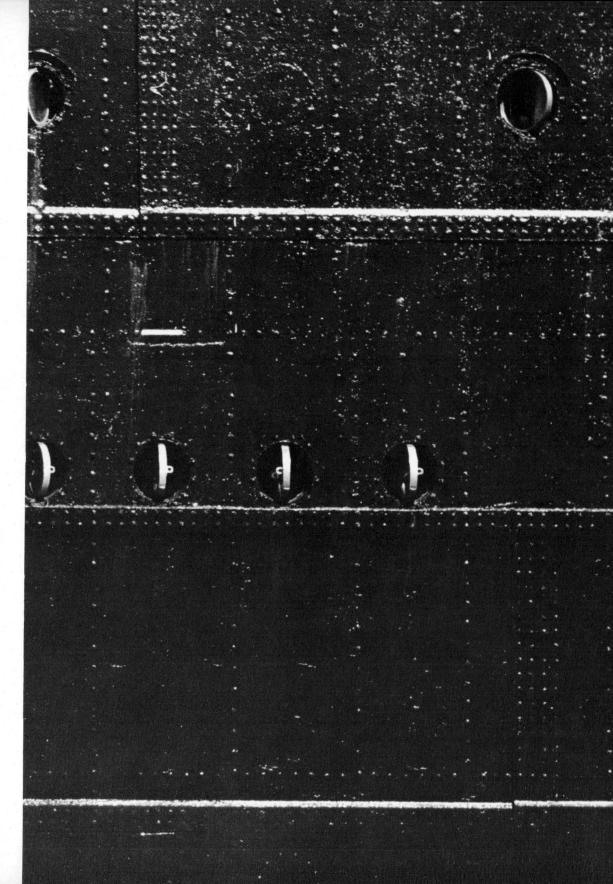

SHIP'S CHEF

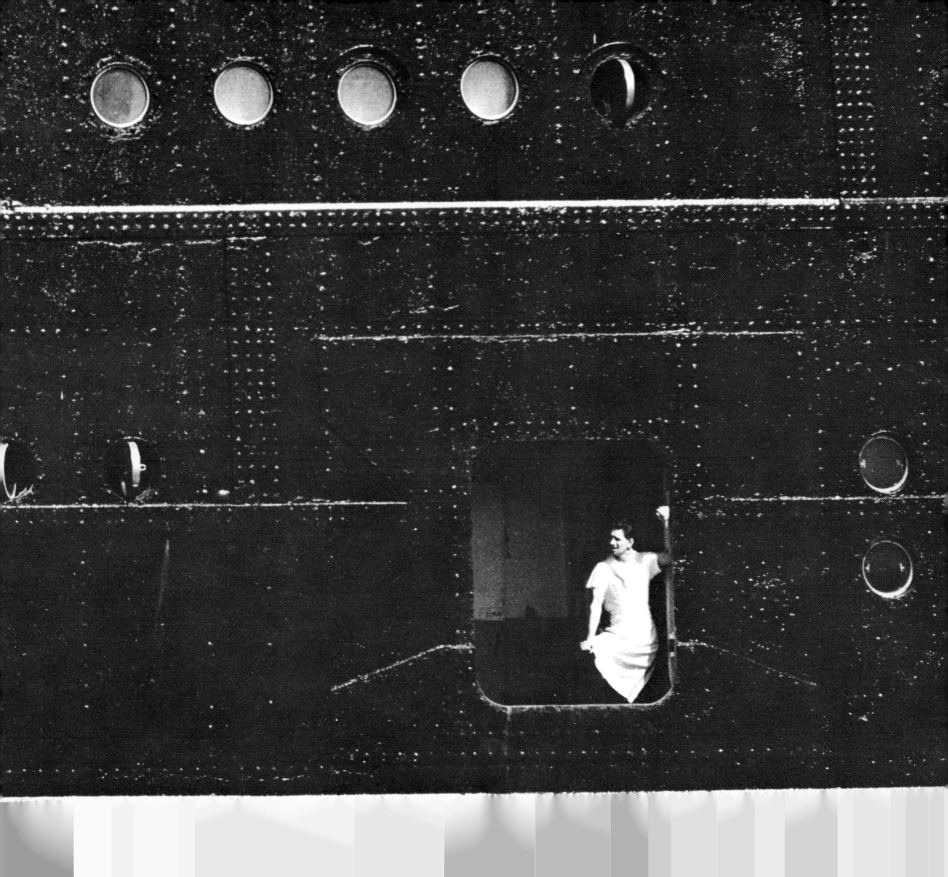

CONSTRUCTION ►

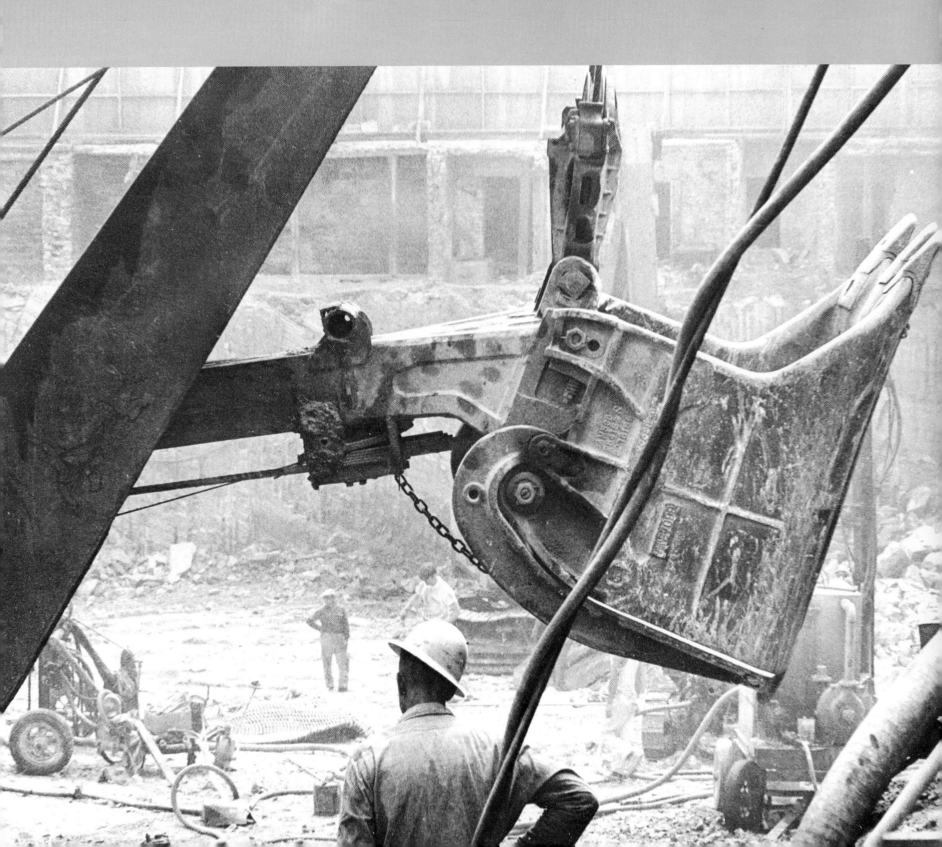

Unity

In order to have unity it is necessary to have a strong dominating force. Just as a country must have a strong government to keep it united, so a picture must have a dominating shape. This shape must be in a dynamic position in the picture area. As a general rule, it should never be located at dead center.

The dominating force should be in approximately the correct position in the viewfinder of the camera when the exposure is made; but enough space should be allowed around it so that minor compositional adjustments can be made under the enlarger. It is incorrect to have a vertical dominating shape on a horizontal format, or a horizontal shape on a vertical format. The strong dominating shape, or positive force, must be surrounded by a supporting area which we can call "negative space."

It was physically impossible to follow the rule of thirds in *Long Distance, Please* (page 68). This brought the dark shape of the man too close to the margin, but the negative space is interesting, and supporting enough, to occupy the large area. The exposure was extremely critical as the details were desired in both the light and dark areas.

The Man (page 69) was taken at a display in a museum. The shadowless light and the white display in the showcase formed an ideal background for this picture. The shape of the man, in this case properly positioned in the one third area, provides the dominating force as well as the focal point.

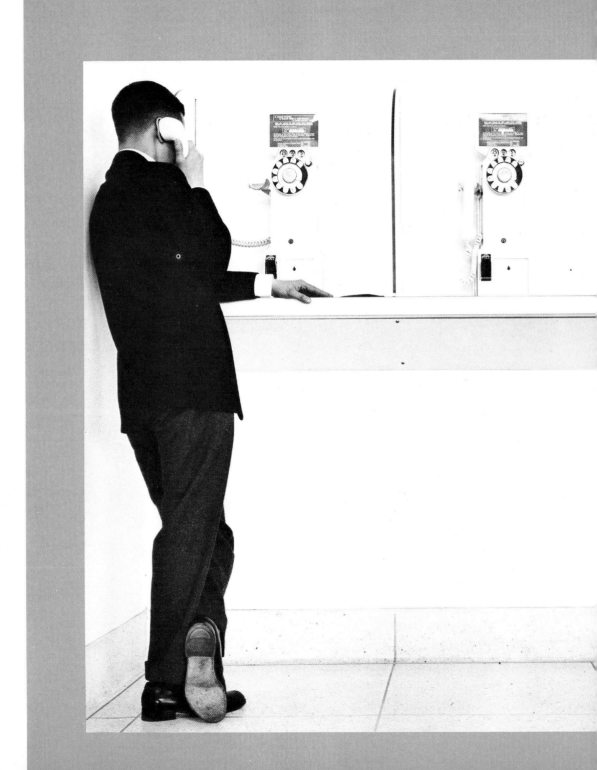

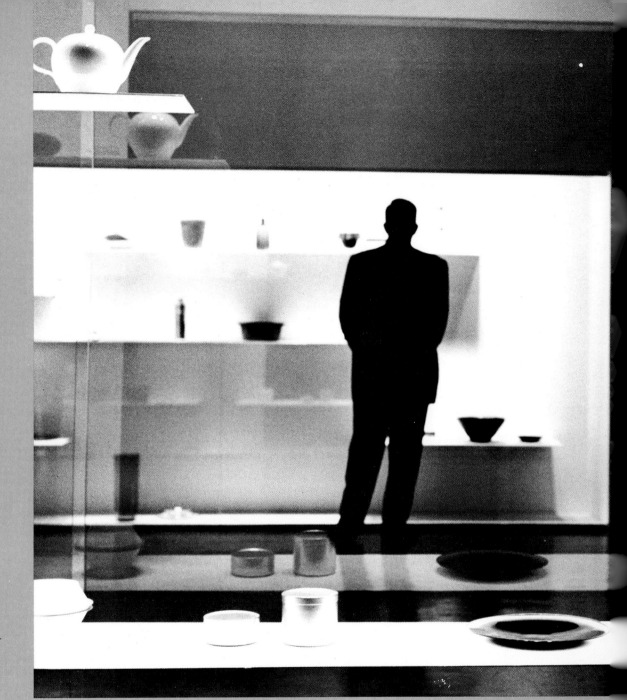

THE MAN

◄ LONG DISTANCE, PLEASE

Gradation

Gradation is the gradual changing of one shape or tone into another, such as light into dark or small to large. As photographers we must recognize this phenomenon, since it appears in our pictures. If it does not, we must deliberately seek it out.

Gradation is obtained in *City Winter* (page 71) by the atmospheric change caused by the slowly falling snow. It is given added emphasis by the receding and overlapping shapes of the roof tops. An exposure of one hundredth of a second was used to stop the motion of the snowflakes.

Misty Park (page 73) is one of the unexpected bonuses of a field trip. A sudden fog obscured the sun, giving the picture its luminescent quality.

East River Pier (page 75) shows gradation through atmospheric haze and perspective by overlapping shapes. The dense atmosphere was emphasized by using a 200mm lens on a 35mm camera. On the exhibit print I intensified this condition by blue-toning the distance and brown-toning foreground objects.

Diversity (page 77) was taken with the camera positioned a block away from the cathedral, and using a long lens. The long camera-to-subject distance was necessary in order to avoid distortion usually caused by standing too close to a tall subject and pointing the camera upward. The office buildings looming up on either side form a canyonlike funnel toward the distance.

CITY WINTER ►

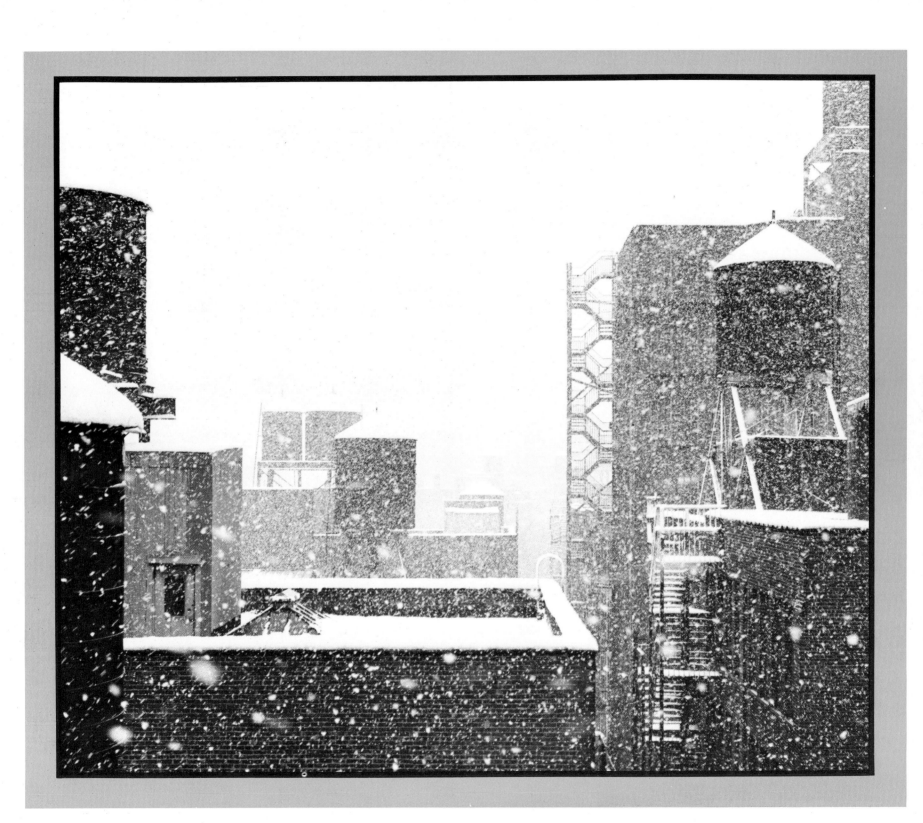

MISTY PARK ►

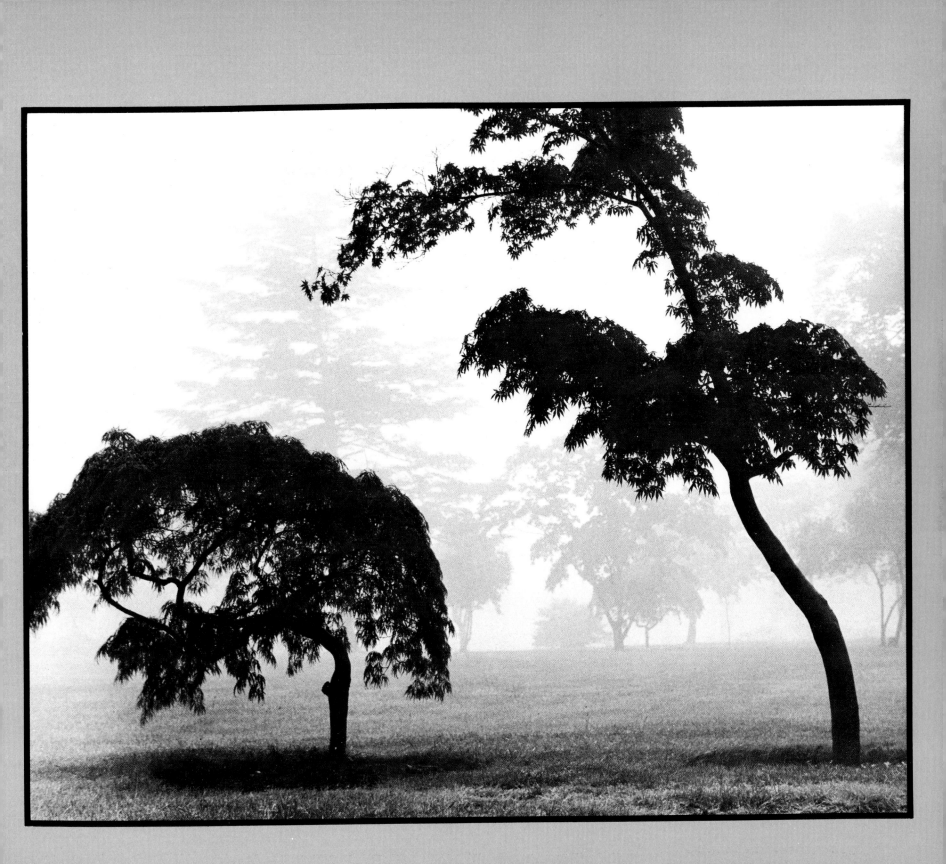

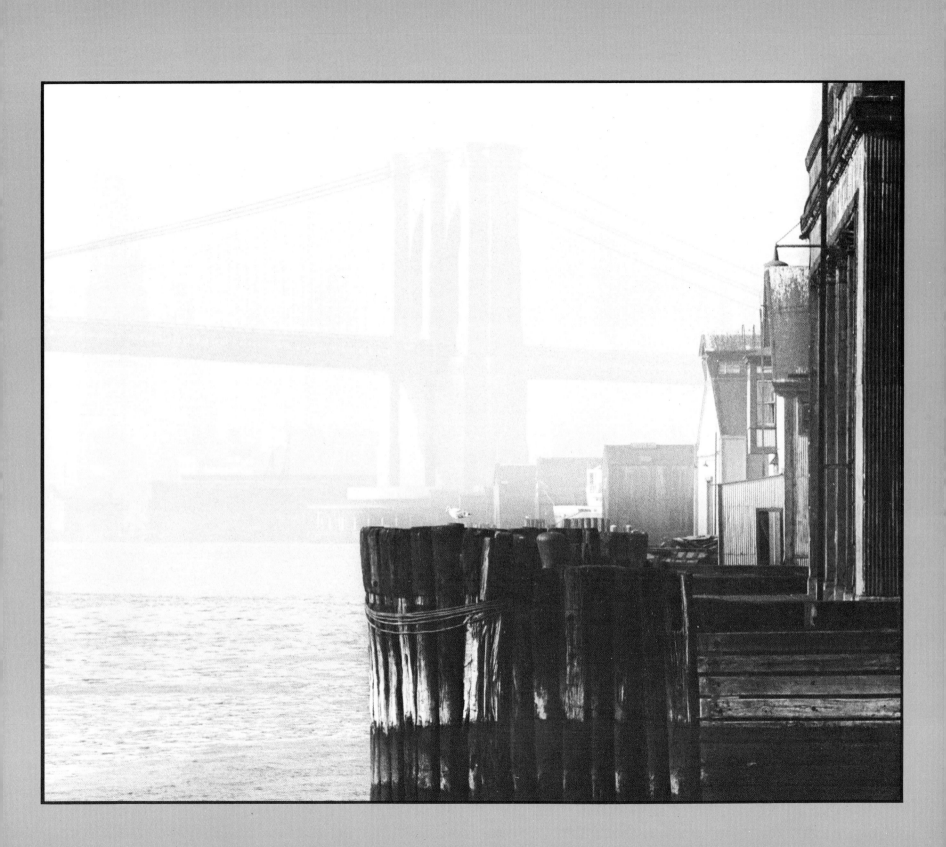

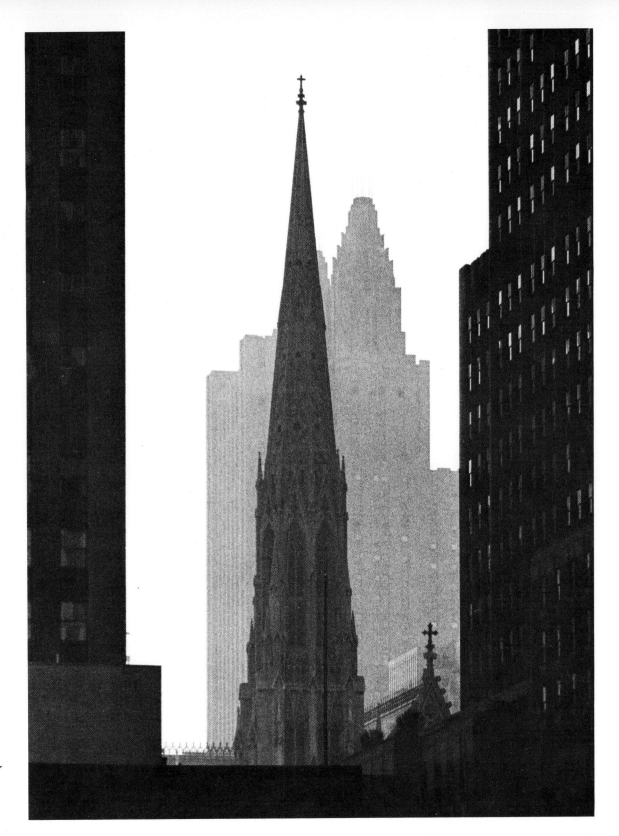

DIVERSITY

Formal Balance

A formal composition is the arrangement of equal shapes placed to the right and left of the picture axis. Forms used on the right side of the axis must be repeated on the left side and the inclusion of any distracting elements must be avoided.

This form of composition was originated by the architects of the Renaissance who wished to demonstrate formality and dignity in their creations. The idea was also used by the painters of the era, and the most famous painting illustrating this precept is undoubtedly Leonardo da Vinci's *Last Supper*. Formal balance was used almost exclusively up to the time of the French Revolution, and it is still employed today, although a more vibrant form originated in the mid-nineteenth century.

Solitude (page 79) is the picture of a structure in a modern city isolated from its surroundings by falling snow. The dark shape in the foreground is the factor which divides the picture into two equal parts. I waited a long time for such a shape to appear, because without it the axis necessary for a composition of formal structure would be missing. While

many people, guessing at the location of this building, have placed it in various European cities it is, in fact, located at the approach to the Manhattan Bridge near the end of Canal Street in New York City.

Once again, it paid off to wait. When one man appeared carrying the beam on his shoulder, he provided the fulcrum for the composition and I made my exposure. Under the title *Construction Worker* (page 81), it became a very successful print.

The Spectators (page 85), as is true of most of my work, was unposed. I visualized the pictorial possibilities of the situation as soon as I saw it. Here the picture is balanced by the children clustering around the central frame of the window. In order to avoid distracting elements, it was necessary to darken a number of small areas with Spotone on the finished print.

The formal composition of *Landscape with Birches* (page 83) was created by the repetition of the trees in the foreground and the parallel horizontal bands. Notice the tonal shift in the upper part of the trees.

SOLITUDE ►

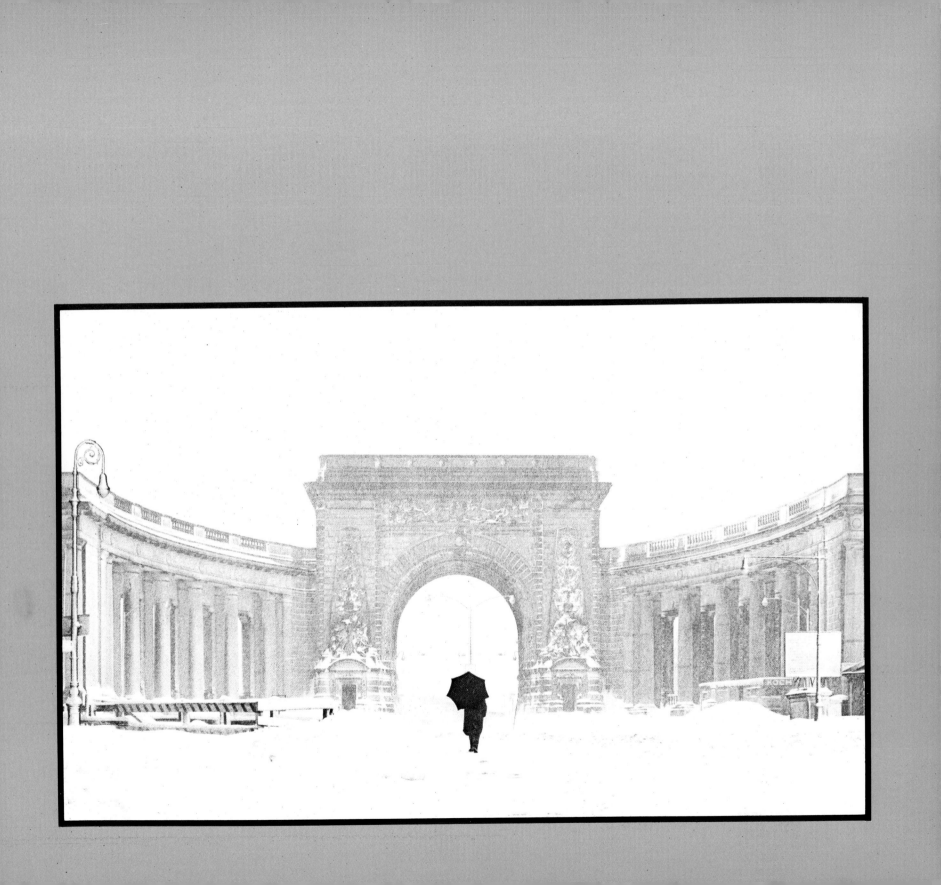

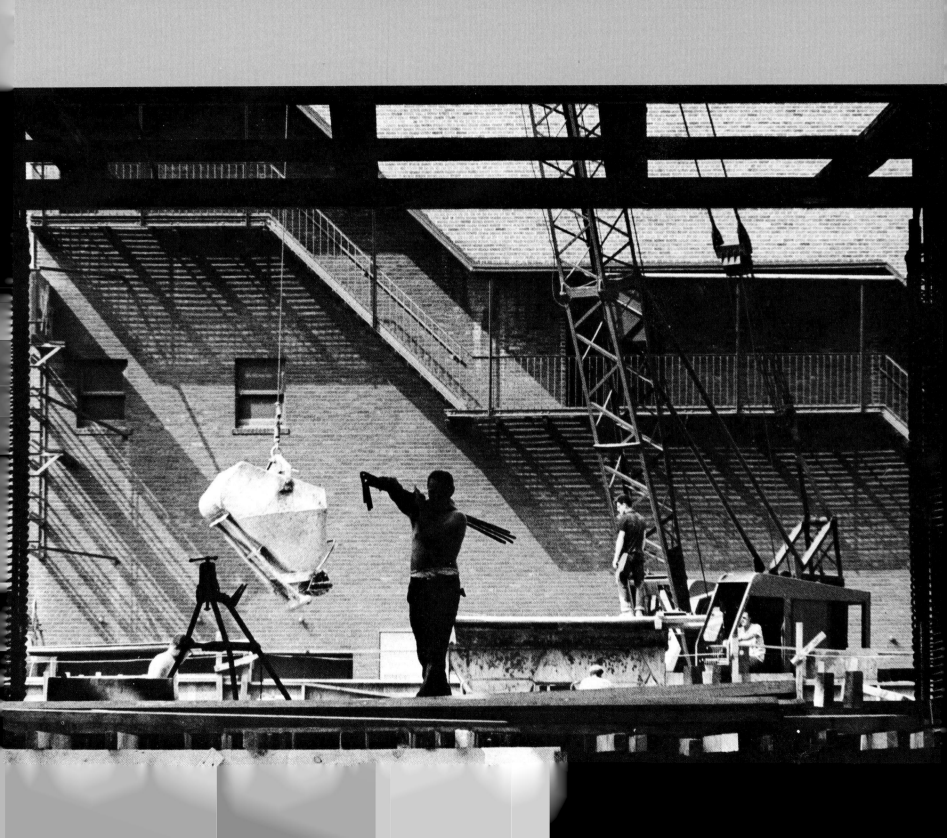

LANDSCAPE WITH BIRCHES

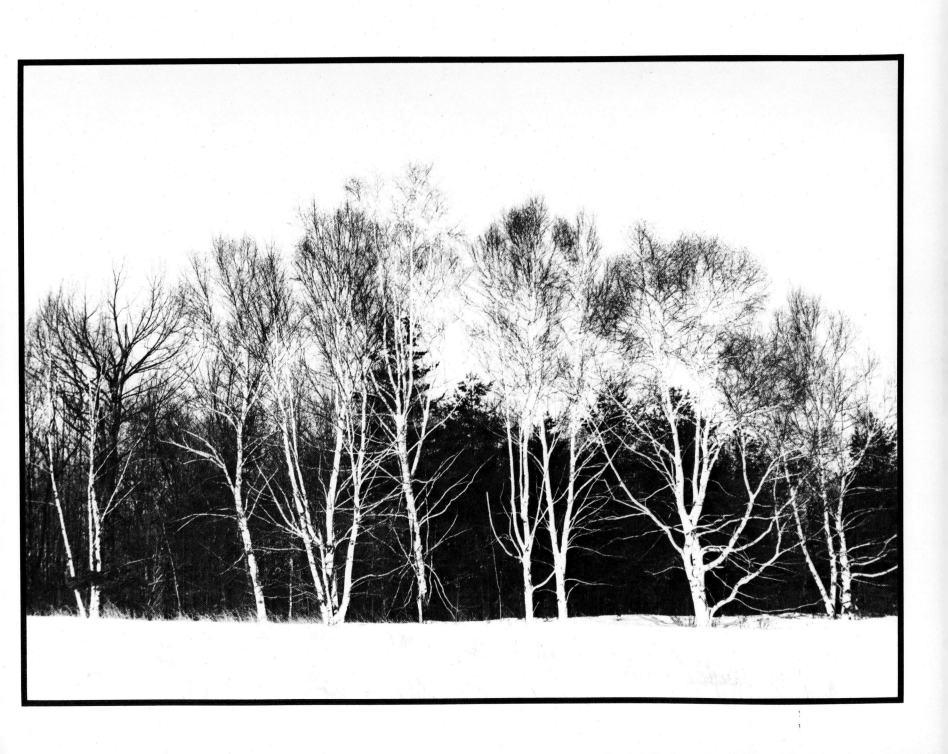

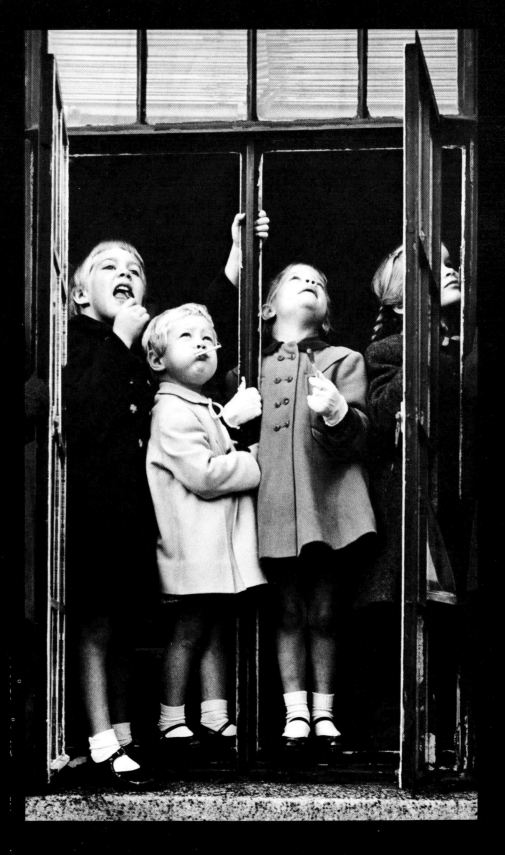

THE SPECTATORS

Informal Balance

The French Revolution at the end of the eighteenth century destroyed not only the country's nobility, but its art activity as well. What followed was chaos. The young artists of the nineteenth century wanted to start something new. They were not in sympathy with the formal composition of the past, so they invented informal arrangement. Informal balance was nothing new; it could be seen every day on the scales used by the sidewalk vendors. These scales use the principle of the steelyard balance, in which the large weight is counterbalanced by the small weight on the long arm of the scale.

In their Paris exhibition in 1874, the avant-garde artists showed many informal compositions. Among them was Degas' *Dancers on the Bar,* in which he portrays two dancers exercising on the right half of the bar, counterbalanced by a watering can in the lower left corner. The contemporary viewer might ask, "What has a watering can to do with two dancers?" Seemingly, nothing, but it was used to wet the floor in order to keep the dust down.

Electricity and the vacuum cleaner had yet to be invented. That can, moreover, provided the balancing element in the artist's composition.

Slowly the architects followed the lead of the innovative artists and began to design buildings using the steelyard balance. Of course, formal balance was still used for cathedrals, government buildings and theaters and even now is often found in civic buildings.

Unlike the painter or architect, the photographer does not always have time to consider and arrange a certain composition. It may happen suddenly and he must react quickly. This is exactly what happened in *Fountain and Youth* (page 87) and *Two Worlds* (page 89).

In *Fountain and Youth* I achieved the informal composition by counterbalancing the building in the background with the child. A relationship also exists in the striped dress of the girl and the pattern of the building. This shot would have disappeared in seconds.

Again, in *Two Worlds,* the unposed shot would have been gone in moments. It was the little girl, running into the spot of sunlight,

counterbalancing the sailor, which made the informal arrangement. Without the child, no picture would have existed.

The Butcher's Helper (page 91) is a posed picture and I had full control of the arrangement. The man's apron is counterbalanced by the bare bulb in the upper left. The inclusion of this bulb moves the picture out of the portrait class and gives it universal appeal. Incidentally, this print received an Honor Certificate in a Moscow International Salon, but the Soviet exhibitors translated the title to read *Butcher's Assistant.*

The Fisherman and the Gull (page 93), like so much of my work, was achieved by contact printing the continuous tone negative on high contrast material to remove the middle tones. Anyone who has taken pictures of seagulls knows that it would be a hundred-to-one chance that the gull would fly into the precise spot to counterbalance my fisherman. It did not. The gull was borrowed from another negative and printed in after the fisherman exposure was made.

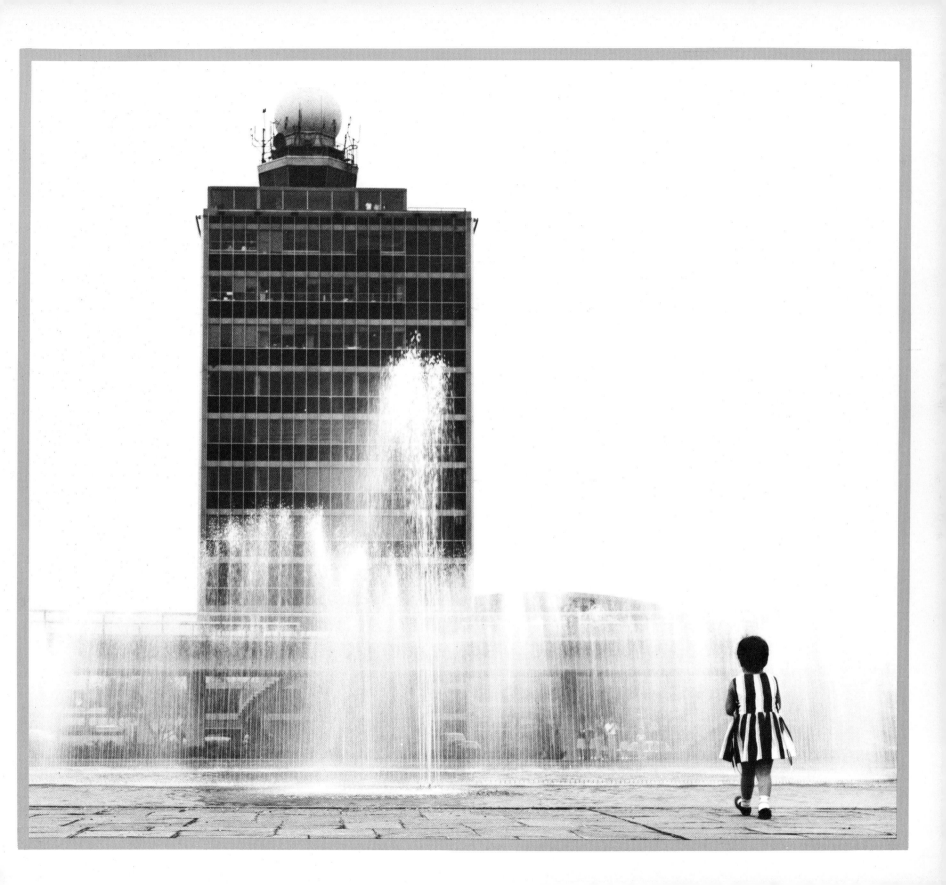

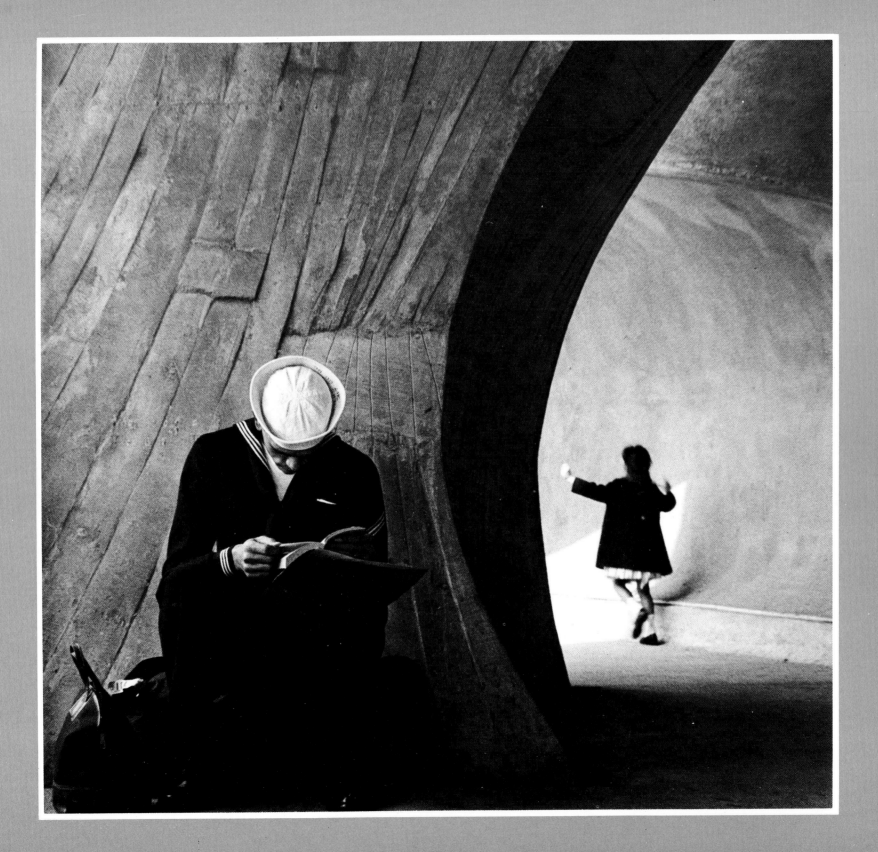

THE BUTCHER'S HELPER ►

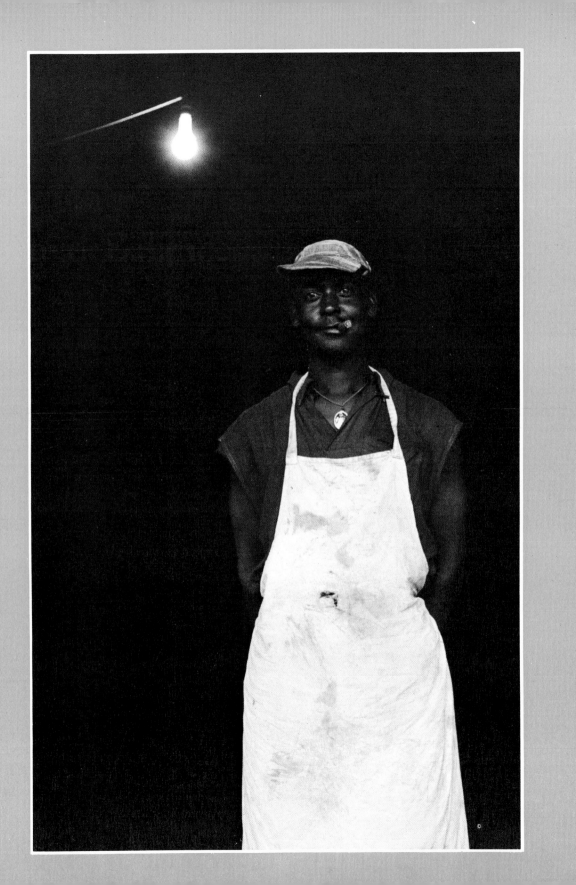

THE FISHERMAN AND THE GULL ►

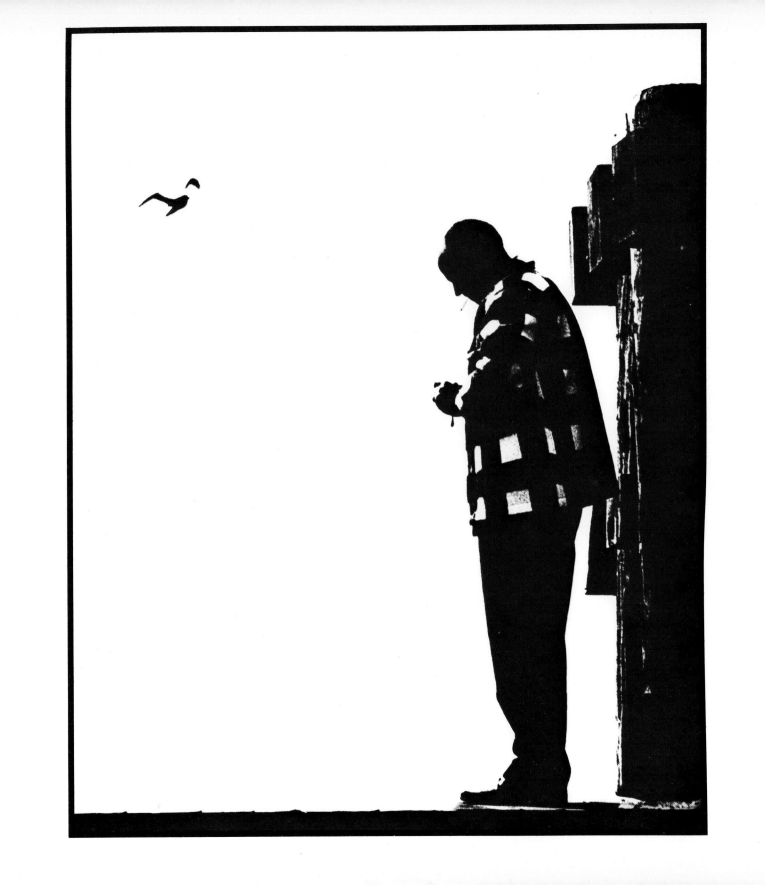

93

How To Compose The Final Print

The composition of the final print must make a clear and concise statement. To a certain degree, the picture is composed on the ground glass or in the viewfinder. Before exposing the film a visual order is created through control of the lines, shapes, and directions within the view. Since the camera often includes a much larger area than is desired in our final print, we must compose again in the darkroom.

Our film has been developed, dried and cut into convenient lengths. Three strips of four frames each of 2¼″ x 2¼″ exposures will cover an 8″ x 10″ sheet of paper; and six strips of 35mm will do the same. Raise the enlarger head to a height of about 20 inches from lens to board, stop down to $f/16$ and set the timer for two seconds. Put a strip of negative on a small piece of enlarging paper and weigh it down with an 8″ x 10″ sheet of quarter-inch glass. Cover most of the strip with a piece of cardboard or any lightproof material and expose the strip at two second intervals, moving the cardboard to expose more of the strip for each exposure, until you have five or six exposures. You'll probably discover that the correct exposure for the contact prints from normal-density negatives is usually about six or eight seconds. Now place the negatives, emulsion side down, on a piece of 8″ x 10″ paper, weigh them down with a

clean 8″ x 10″ glass which is free from scratches, and expose. After developing and drying, examine the proof sheet and mark the frames having the best possibilities for future enlargements.

Now enlarge each of the selected frames on an 8″ x 10″ sheet of #2 projection paper, using the entire negative with no corrections. After the enlargement is washed and dried, secure a double sheet of tracing paper over the face of the print. This will block out details and grey tones, helping to concentrate on the basic composition. With crayon or nylon-tip pen, shade in the dark areas, creating an abstract compositional design.

To determine which shapes should be used, move two "L"s over the design on the tracing paper, and once satisfied with the arrangement, transfer the outline to the print beneath. Regardless of the subject matter, this will be the format of the final enlargement. It will rarely conform to the pre-cut, stock format of the enlarging paper.

You must now discover the measurements of the new picture, so take the negative and enlarge only that part of it which you selected from the original 8″ x 10″. When you have obtained that composition, measure the new outline. Turn off the enlarger light and transfer these measurements to the back of a fresh piece of enlarging paper. Now cut the paper

to these dimensions and save the scraps for test strips. Replace all paper and trimmings in the envelope and proceed as follows.

First recheck for sharpness with the enlarger lens at full aperture for maximum brightness and visibility. Then stop the enlarger lens down to $f/11$. If the image still seems too bright, which would necessitate a very short exposure, stop down to $f/16$; if too dark, necessitating too long an exposure, open up to $f/8$. Next, look for a spot which includes light and dark areas and cover it with a thin sheet of cardboard about 4″ x 5″. This will be your test area. Turn off the enlarger light. Take a piece of enlarging paper about 2″ x 5″ and make sure it is flat. Place it on the exact spot where the test strip is to be made. Now cover the test strip with the cardboard, leaving about one half inch uncovered. Expose for five seconds. Then, holding your test strip down with thumb and index finger, move the cardboard down another half inch and expose again. Repeat this until the entire strip is exposed. Develop in #1 tray, which contains one part of Dektol to two of water, for two minutes under continuous agitation. Transfer to #2 tray, containing short stop, and after a few seconds, to #3 tray, containing hypo. Tongs should be in every tray. After a few minutes in hypo we can turn on our white light and examine the strip. The section where dark

and light are properly exposed in relationship to each other will be our final exposure, which should be no shorter than thirty seconds or longer than one minute.

Occasionally a negative is unbalanced and the print to be made from it will need different exposures in certain areas. To do this correctly, the exact exposure must be determined by making a test strip of each area. If additional exposure is needed in a certain area, shade the enlarger light with your hands to cover the rest of the print. In other words, burn in that particular part. If, on the other hand, a certain area would print too dark during the normal exposure, the light must be held back from that area with the hand or with a dodger.

To create a definite edge on the print, a black border should be included in printing. With the enlarger lamp off, remove the negative holder from the enlarger and set the timer for five seconds. Place a steel ruler along one edge of the print leaving 1/8″ exposed, then cover the rest of the print with a large cardboard and expose. Turn your easel to the left and cover again with 1/8″ exposed. Make sure that the cardboard covers everything else and expose again. Repeat for the other two sides, always turning the print in the same direction.

Develop the print in the same manner as the test strip. Keep it face down in the hypo tray under continuous agitation to prevent yellow stains from forming. After about five minutes turn the print over and examine it under room light.

The things to look for during this examination are good, solid blacks, clear highlights, and over-all contrast. There is nothing worse than a muddy print, containing neither black, nor white, nor proper contrast.

If contrast is lacking in the first print, you must make another test strip, exposing it the same time as the first one but increasing the development time to five minutes. Choose the proper contrast from one of the exposures on this strip. Since the developing time is longer, the proper exposure time will be less than that of the first print.

If the contrast in the first print is too great, the exposure time can still be the same as the test strip, but the developing time must be decreased to a minute and a half. In this case the proper exposure time will probably be greater than for the first print. All of this information is for users of #2 paper only. If available, substituting #1 or #3 paper will automatically adjust contrast. Once you are satisfied that your print has the proper tonal and contrast qualities, you are ready to make as many as needed. For future reference all the information pertaining to exposure and developing should be noted on the back of the print.

After you remove your prints from the hypo, wash them thoroughly for half an hour in warm water, then swab the excess water off and place them on blotters emulsion side up. As soon as the corners curl up it is time to put the prints between old mounts and weigh them down, preferably in a press, until they are thoroughly dry.

Trim the dry print, using a steel rule and a sharp cutting knife, leaving about 1/16″ of the black border.

At last you are ready to mount the print, but first you must find the place on the mount which will compliment the composition. Place a 16″ x 20″ sheet of mounting board on the floor with the print in the middle. Now stand up and examine this arrangement. If this is not satisfactory, move the print down to the lower left hand corner of the mount. If it is completely out of place there, move it over to the lower right hand corner where it may seem to be in the correct position. Such shifting can lead to discovery. If, for example, the composition of the picture is open toward the upper left, you can continue this movement by placing it in the lower right corner of the mount. No matter where the print is placed on the mount, a separating margin must always exist between the edges of the print and mount.

When the print is correctly placed, draw a light pencil line around it. Next, spread a thin coat of rubber cement on the mount within

the boundary of the pencil line; then apply a coat of cement to the back of the print. Allow the cement to dry for at least twenty minutes. Now cover the rubber cement on the mount with a heavy piece of brown paper, leaving only ¼″ of it exposed. Place the print on the mount, being very, very careful to get it within the pencilled line since, once placed cement contacts cement, the print cannot be removed. Take a cloth and press down on the area, then pull the paper back about 1″ and repeat. Continue until the entire print is mounted.

Now you are ready to etch and spot the print. Dark, unwanted spots and pinholes must be removed first. For this, use a new double-edged razor blade which has been broken in half while still in the sleeve. Take one half out of the paper cover and, holding it between the thumb and index finger, place the entire edge on the paper. By holding it at an angle to the print, you can use only the very edge to remove spots. This position will not scratch the paper base but will shave off the emulsion coating. In this way dark spots can be removed and highlights added. It is a good idea to practice this technique on old prints.

When the etching is finished, turn your attention to the white spots. There are certain tricks which make spotting easier. Take a small saucer, a #2 watercolor brush and neu-

tral Spotone. Fill the brush with Spotone and, starting at the outer edge of the saucer, paint a spiral into the middle of it. By then your brush will be almost empty and you'll see that the spiral became lighter and lighter as you went toward the center. While waiting for the Spotone to dry wash out your brush. Wet your brush on your tongue and pick up the appropriate grey tone from the spiral. Then, apply dot after dot until the whole light area is covered and blends with the surrounding tones. If your negative was dust free, spotting should take only a few minutes.

The print should next be waxed to protect the surface and give it additional sheen. Butcher's Bowling Alley Wax is excellent for this purpose because it is clear and leaves a hard finish. Cover the entire print evenly, using a wad of soft cheesecloth, and polish with a soft flannel cloth.

Now the time has come to consider a title, a dignified title, because a silly one only causes laughter and a low score in competition. The title can be hand printed under the edge of the print in the lower left hand corner, and your name opposite, but this is not necessary. However, it is essential to put title, name and address on the back of the mount.

When the print is finished, the question of what to do with it arises. The first step is to enter it in camera-club competition. There

you'll get the viewpoint of others and the criticism of an outside judge. If it is accepted for display, it goes into inter-club competition where the rivalry is even greater. The idea behind entering into competition is not just to try to amass ribbons and medals, but to gain knowledge. You'll learn from the judge's comments, from the criticism of more experienced members, and from viewing the works of others. Eventually you may find your prints doing well and decide to enter them in international salons. This is perhaps the greatest step in a photographer's life because his prints will then be in competition with the work of the world's best photographers and print-makers. Camera clubs and major state fairs throughout the United States run many international salons and every country in the world has at least one. The Photographic Society of America recognizes about one hundred and thirty salons.

When you send prints abroad carefully choose only the very best because the competition is very great, and also, you will, in a sense, be representing your country. Many potential exhibitors feel the expense of foreign exhibition would be prohibitive, but it is not as expensive as sending to domestic salons since it is only necessary to send unmounted 11″ x 14″ prints. The PSA Journal lists accepted salons and it is easy to obtain entry blanks. Once you are listed, they come every year.

On Abstract Photography

Many times in the past, I have received requests from camera clubs to judge and lecture on abstract photography. It has always been a difficult task. It is one thing to be convinced of the validity of a certain movement in art, and quite another to convince someone else.

For example: Judging a competition on abstract photography, a print of the front of a house taken from an unusual angle comes up and my comment is, "You have to do more to make it an abstract."

The maker is dissatisfied with this response and asks me what further steps he can take toward abstraction. This is a question which cannot be answered in a few words. The only advice I can give him is to go to a museum and look at abstract paintings. But, I know his response to an abstract painting will be the same as that of an untrained judge when confronted with an abstract photograph: "I can make nothing of it. What does it mean? It leaves me cold."

A firm understanding of true abstraction can be gained by studying books on the subject and also by living with a *good* abstract painting. It is bound to draw your attention and

every day you will discover something new—a color harmony you did not see before—a new movement—a new space relationship. Sit in front of it and listen to its silent music with an open mind and an open heart and never again will you say, "It leaves me cold."

It is a difficult job to make a good abstract painting and it is equally difficult to make a good abstract photograph. Let us take a look at the working methods of the artist-painter and the artist-photographer.

The major problem in art is and always will be the division of the surface area—in other words, to compose within a stable pictorial field. In contrast to the realistic painter, the abstract artist is not restricted to painting objects as they are in reality. He has complete freedom to use shapes, color and texture to make a statement which was suggested perhaps by music, by the play of light on rushing water or the color arrangement in a tidal pool. In very rare cases will a painting be conceived and executed at the spur of the moment. An idea may lay dormant in the painter's mind for a number of years. Then suddenly he will knock off a painting in a few hours.

The one thing the painter and the photographer have in common is the problem of surface division; but where the painter composes from the outside in, the photographer must compose from the inside out because he lacks the freedom to arrange the shapes at his disposal.

The primary way the photographer can depart from reality which is represented in the negative or color slide is through darkroom techniques. In black-and-white photography, there are numerous ways to translate what the camera has recorded. Removing the middle tones will result in a strange, flat black-and-white design, especially when started with a color slide. A solarization, too, will eliminate the middle tones, leaving a very delicate line drawing. A tone separation or a double printing are other ways to create a different image, and there are innumerable combinations at the photographer's disposal. The only limitation is our own imagination.

Some abstract illustrations start with a color slide, others with a black-and-white negative. What do they represent? What difference does it make?

SHEETS AND SHADOWS ►

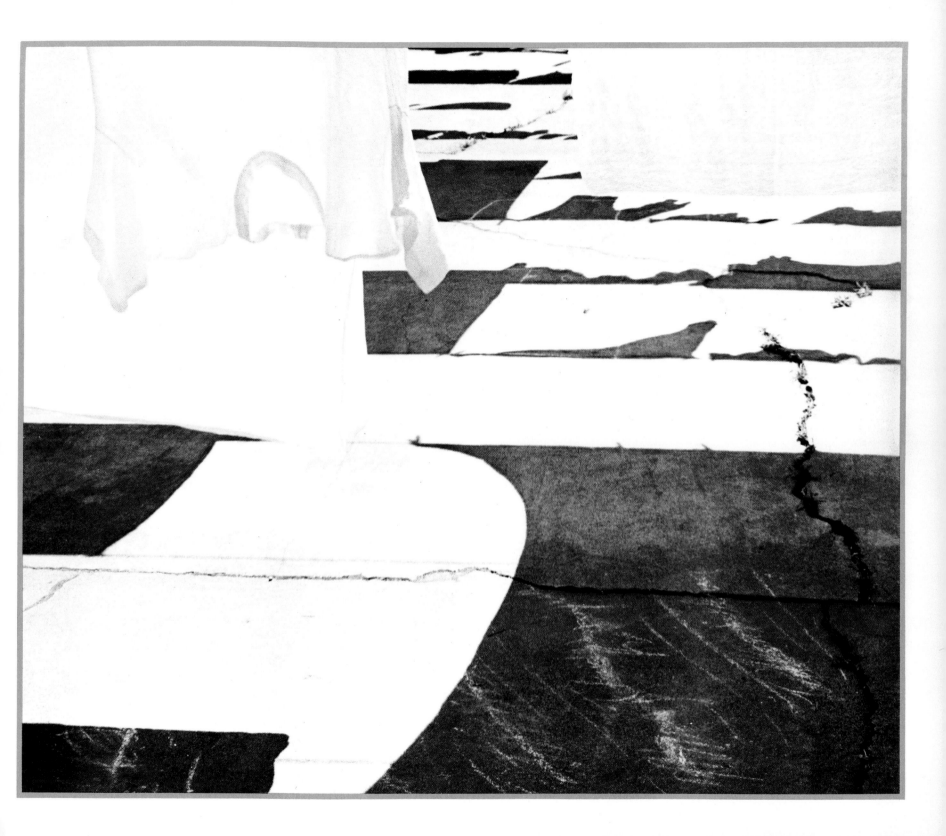

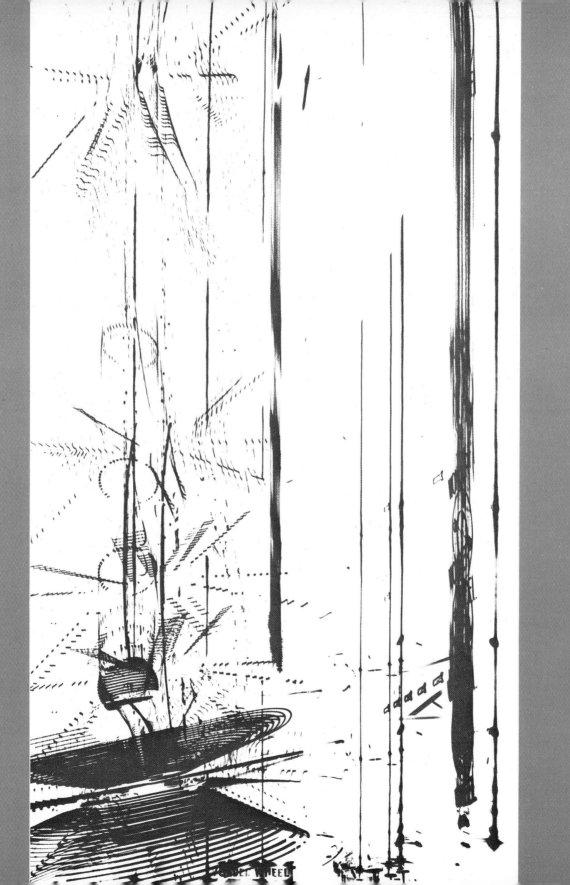

DEVIL'S STAIRWAY

PORTRAIT OF RHYA ►

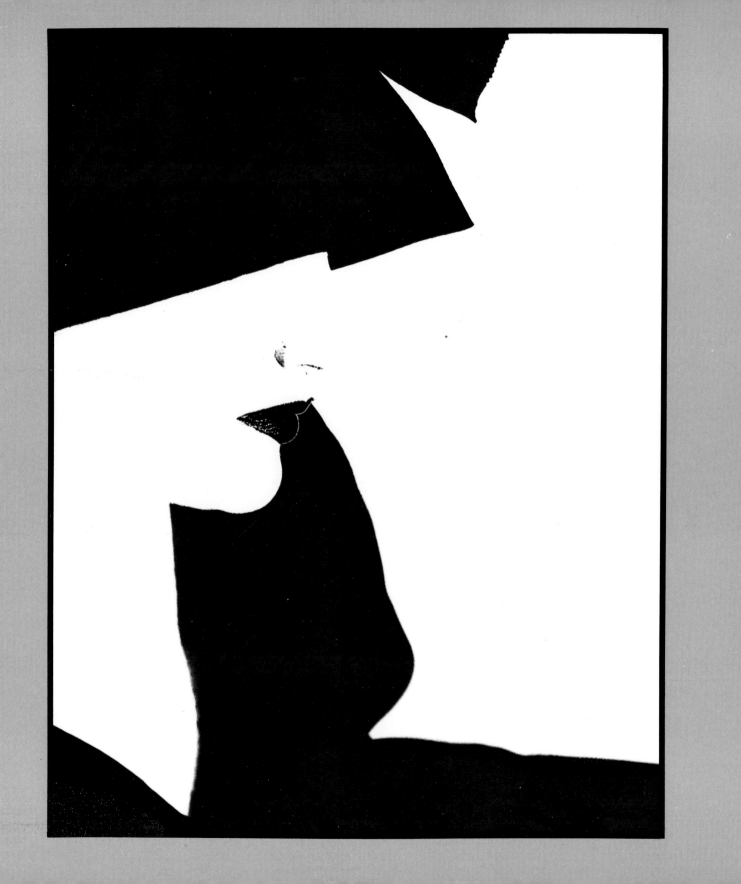

BLACK AND WHITE COWS ►

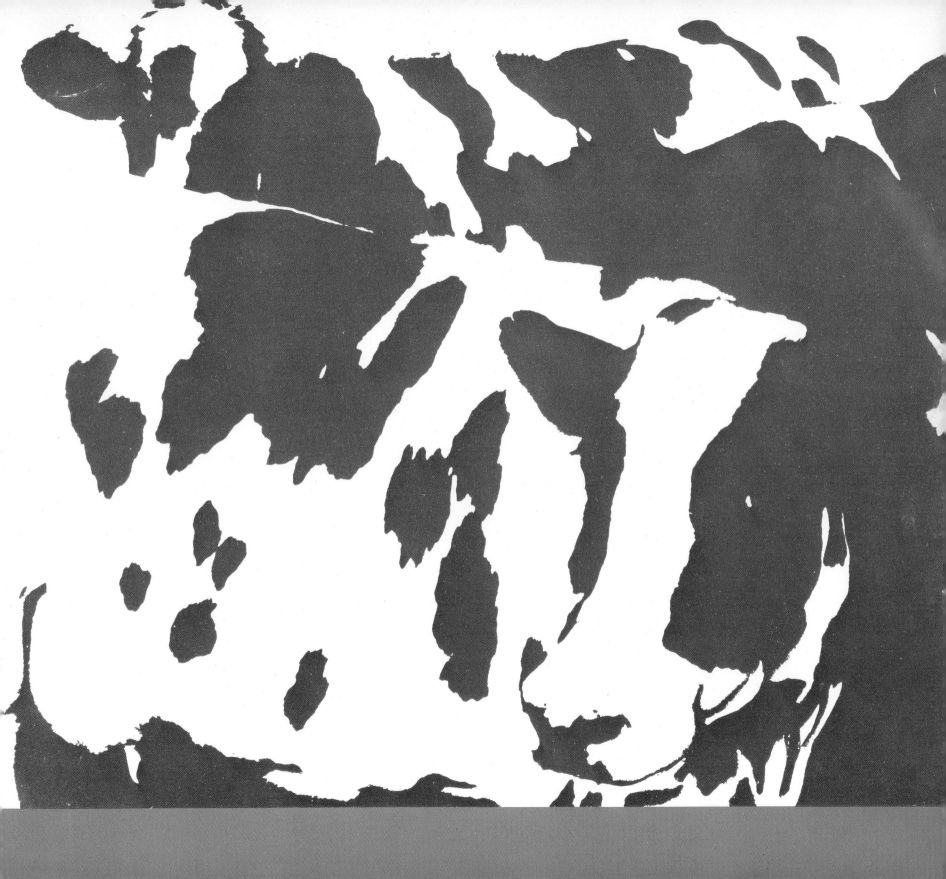

MY NEIGHBOR TOM ►

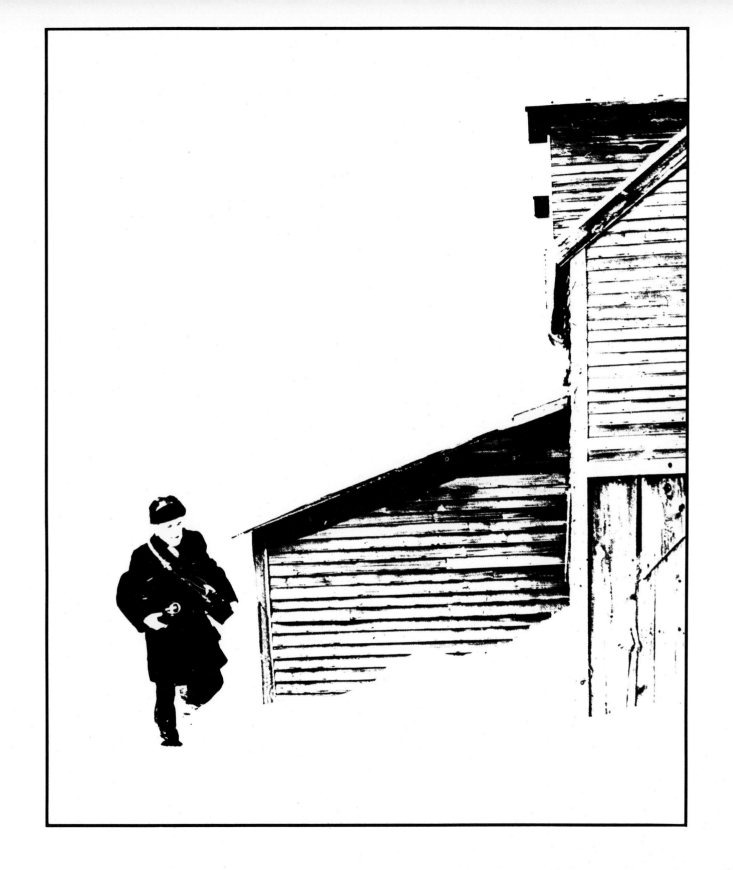

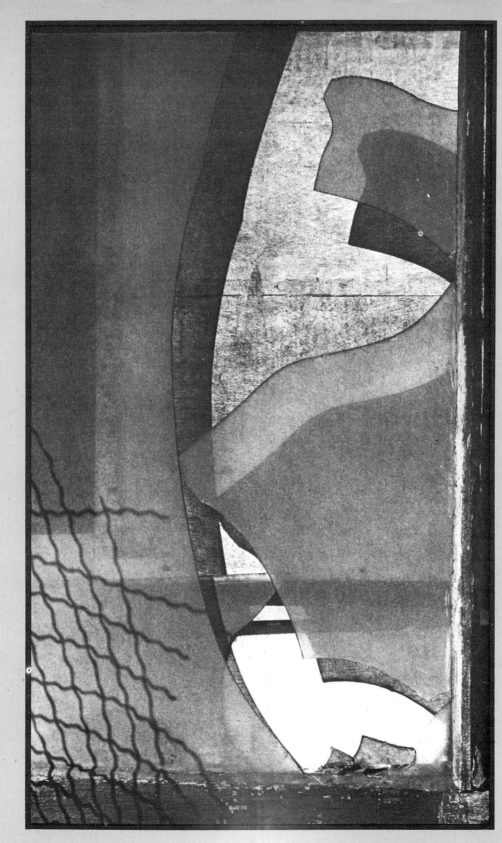

BROKEN WINDOW

Miscellaneous Notes

There are prints which contain only subject matter, depending entirely on its placement in the pictorial field for their effect. *The Swimming Seal* (page 116) and *My Friend, Olaf* (page 117) are examples of this type.

The only reason for taking *The Quarry* (page 115) was the rim lighting on the rocks, which makes a very effective picture.

There are pictures which depend on design alone for their impact. *Blue Granite* (page 122), *Dancing Sun* (page 123), and *Reflections* (page 125) are all examples of this approach.

Strong hands piled up the slabs of granite so as to show prospective customers the shape and size of each stone. It took the artistic eye to recognize a design created by the edges of the flagstones and emphasized by the dark triangle in *Blue Granite*.

The overlapping shapes develop the depth in *Calandro* (pages 118-119). The strong horizontals contribute a sense of serenity. Had the picture been taken from an angle, an indication of movement created by the diagonal lines would have destroyed the static arrangement.

The design of *Dancing Sun* was created by using the principle of the whirling square. The rough textured timbers make an interesting spatial division around the sparkling sun.

The sparkling highlights in *Reflection* (page 125) were created by photographing through two layers of mosquito screening, which were placed directly in front of the lens. Each screen created its own set of rays and the placement of the screens in relation to one another was carefully controlled. The star effect appears only where there is a pinpoint of light.

An observant photographer will discover picture possibilities in both usual and unusual situations. *Cat and the Cactus* (pages 120-121) was taken at the home of a friend. The planter stood on the porch rail and the cat chose the same location to sun itself. When the cat jumped over the cactus, the beautiful rim lighting on the animal and plant caught my attention. I reached, not for my beer, but for my camera. Later, while studying the first enlargement, I became aware of an added bonus—the harmony between the cat's tail and the drooping cactus.

THE QUARRY ►

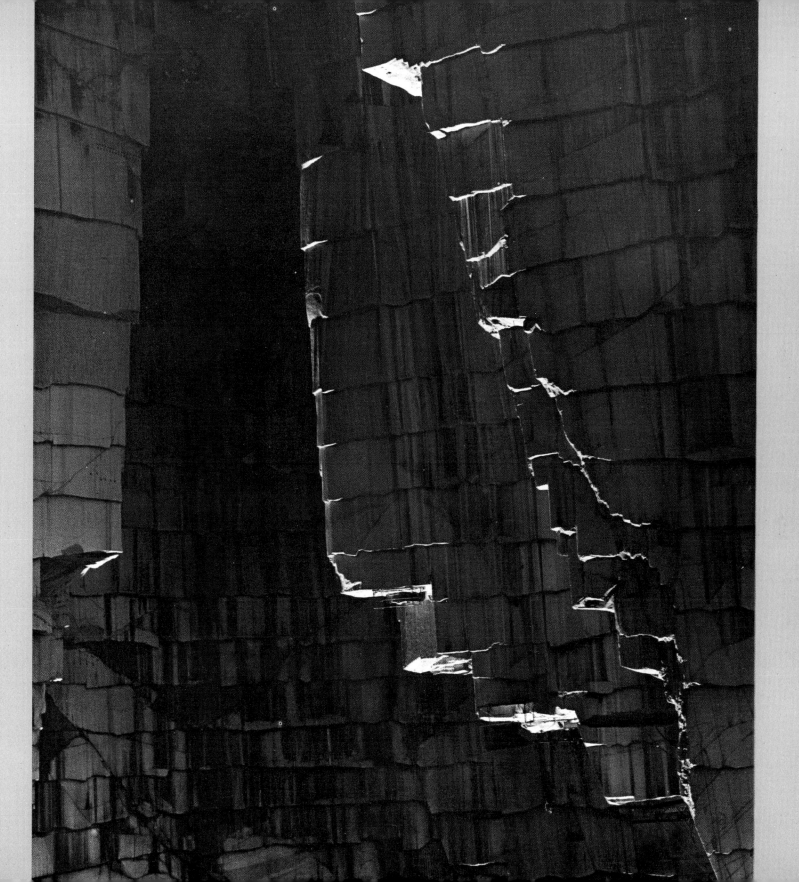

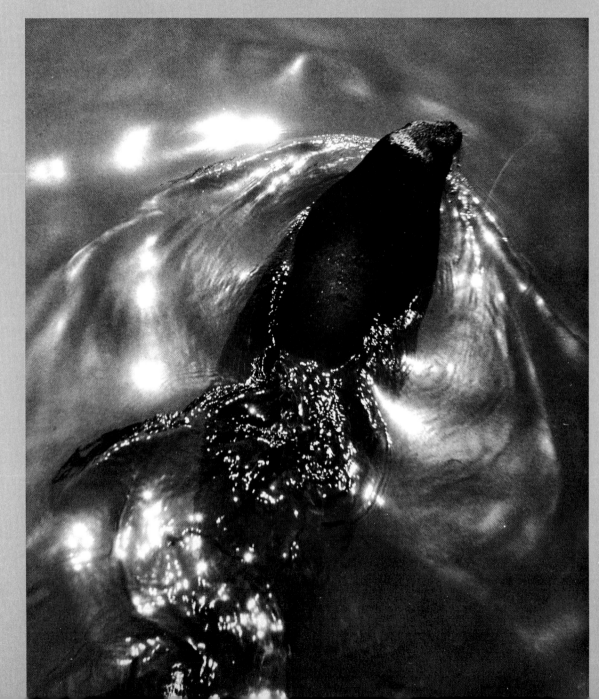

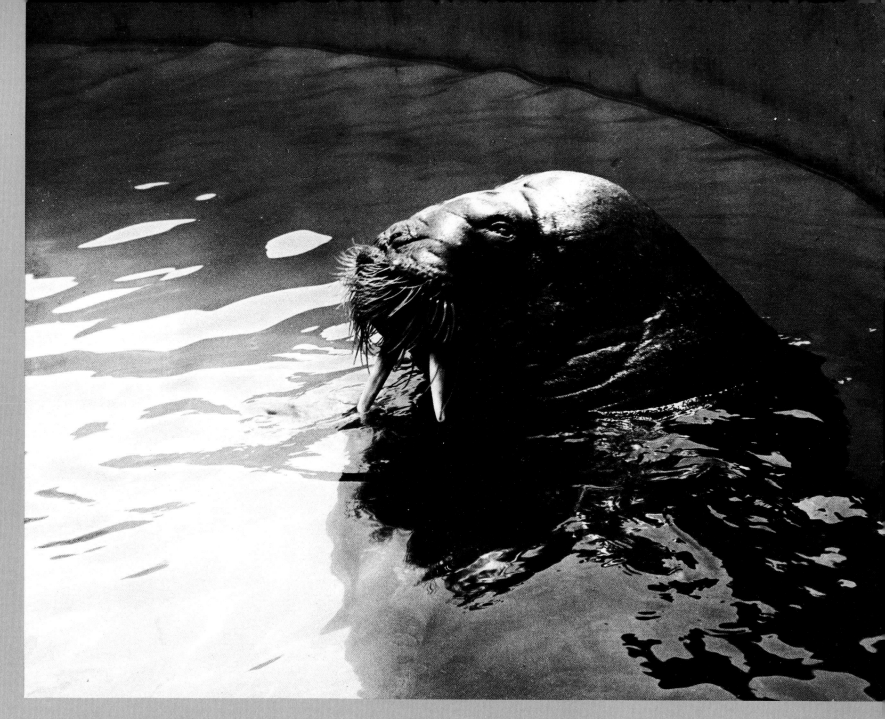

MY FRIEND, OLAF

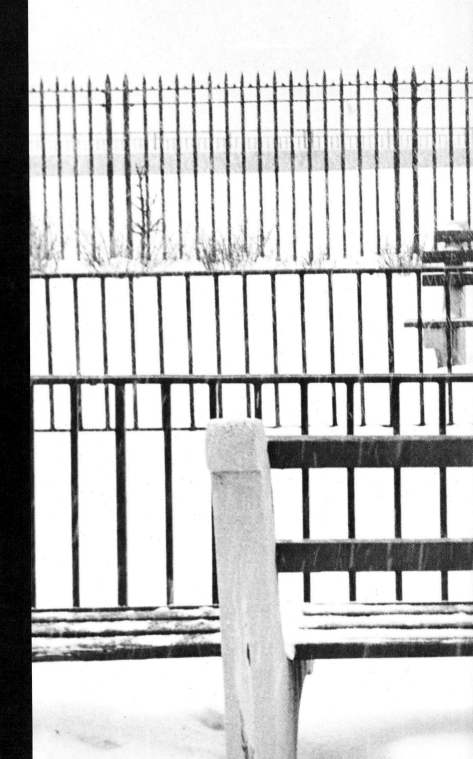

CALANDRO

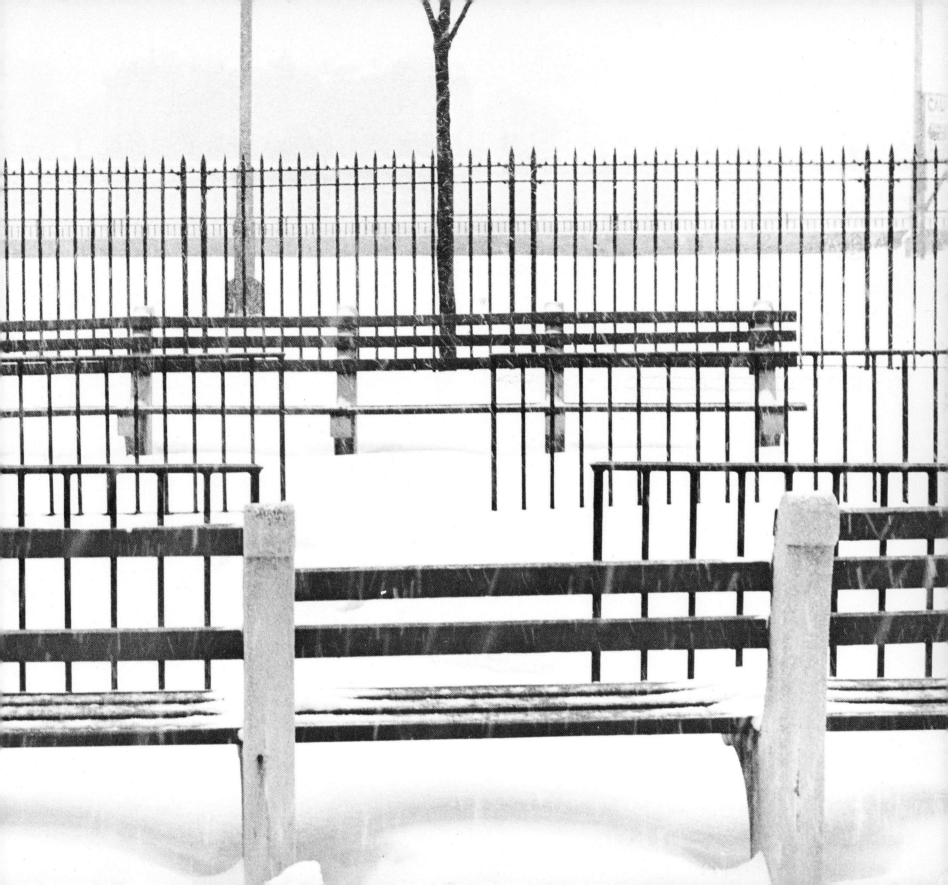

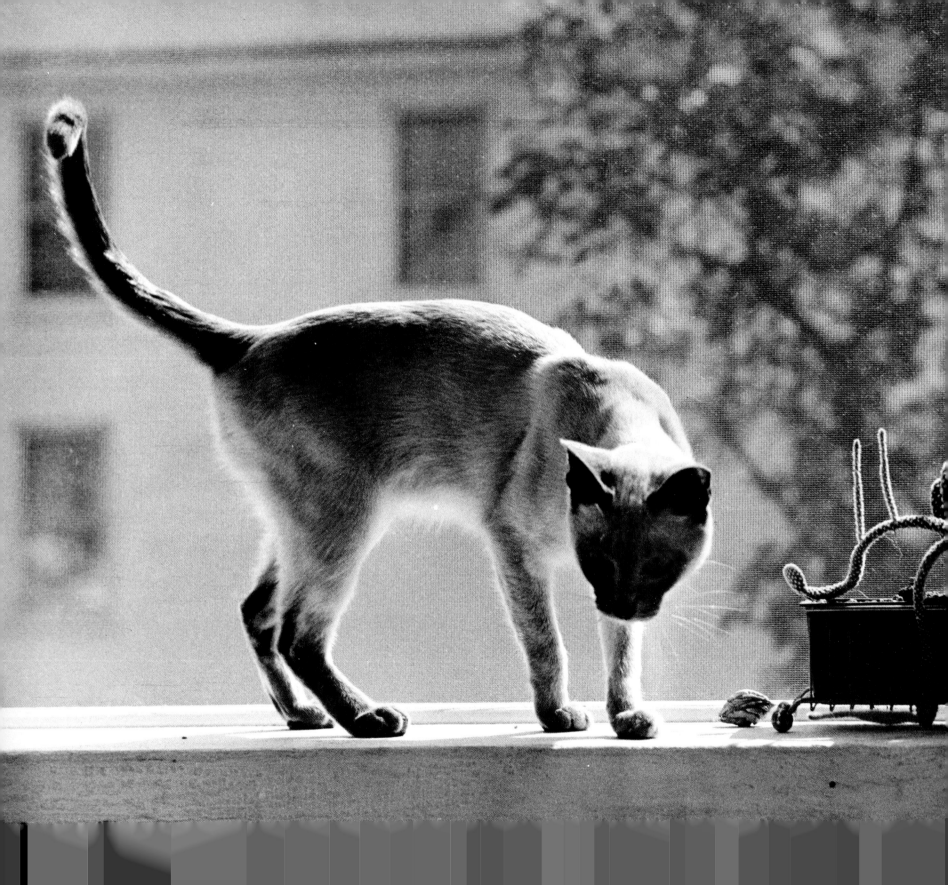

CAT AND THE CACTUS

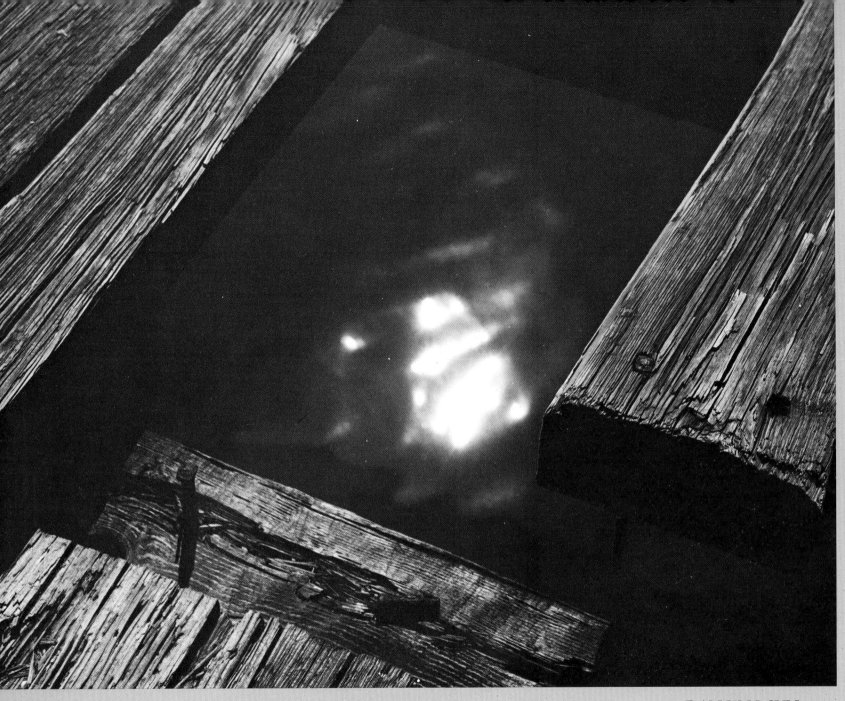

DANCING SUN

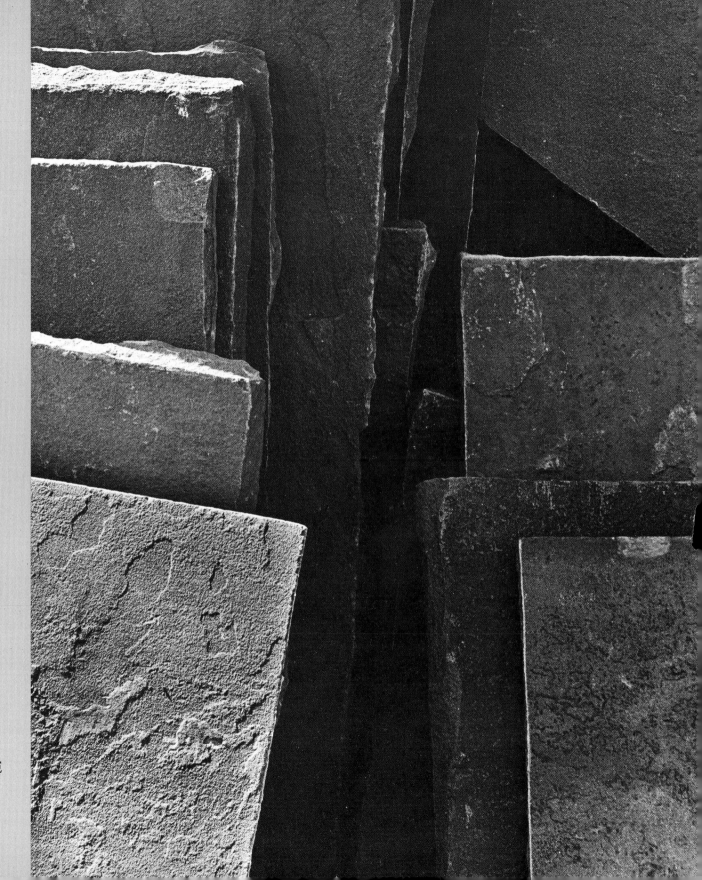

BLUE GRANITE

REFLECTIONS ►

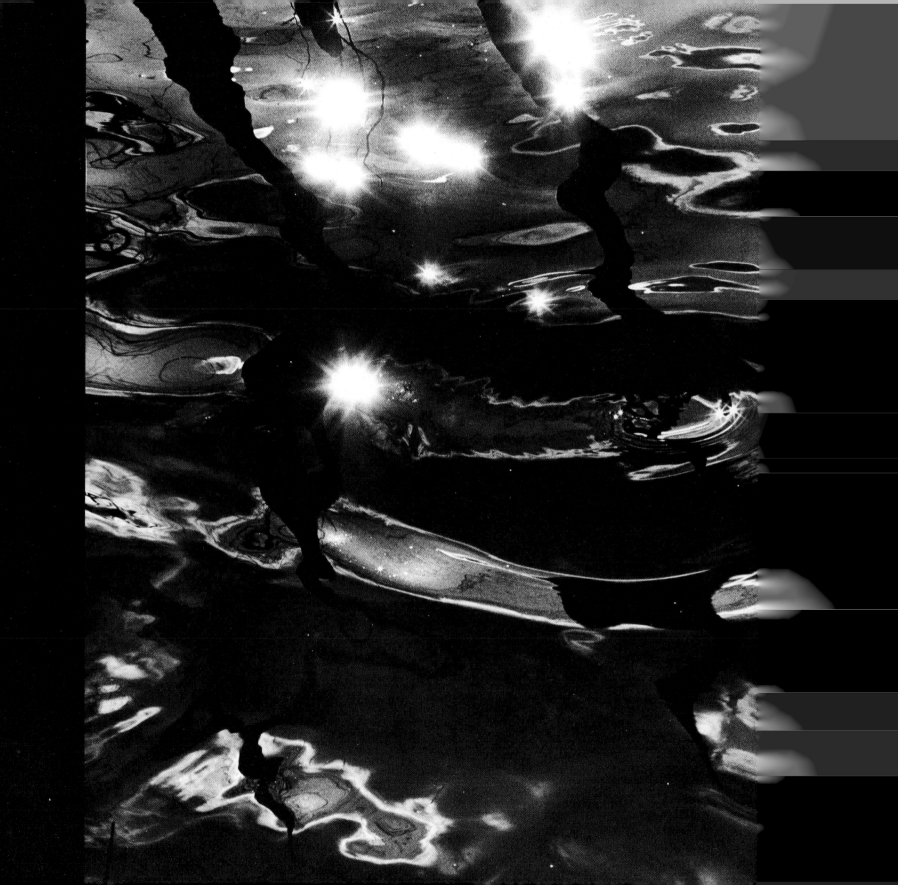

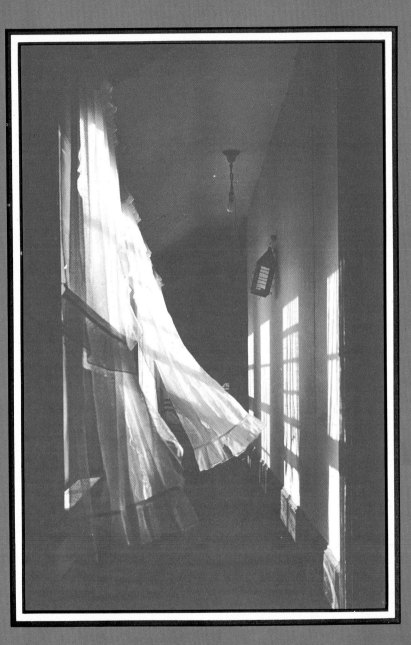

THE CORRIDOR